IMAGES
of America

JEFFERSON

ON THE COVER: The ladies of the Jessie Allen Wise Garden Club purchased the Excelsior House Hotel as a new project. Since women could not get a loan at that time, their husbands had to sign the note. Once the property was theirs, the ladies rolled up their sleeves and began working on the hotel; everyone was assigned a room to restore and decorate. It is now a showplace for visitors to Jefferson. (Courtesy Jessie Allen Wise Garden Club.)

IMAGES
of America

JEFFERSON

Mitchel Whitington

ARCADIA
PUBLISHING

Published by Arcadia Publishing
Charleston, South Carolina

Printed in the United States of America

Library of Congress Control Number: 2011938166

For all general information, please contact Arcadia Publishing:
Telephone 843-853-2070
Fax 843-853-0044
E-mail sales@arcadiapublishing.com
For customer service and orders:
Toll-Free 1-888-313-2665

Visit us on the Internet at www.arcadiapublishing.com

*To my good friend and compadre Delbert Johnson, whose love for the
City of Jefferson knew no bounds*

CONTENTS

ACKNOWLEDGMENTS

I am truly in awe of the number of people and organizations who have an intense love for the city of Jefferson and wish to see its history not only preserved, but also proclaimed. I started this project with the idea that I was well acquainted with that history, but this book has been an incredible education for me—there are photographs that I had never seen before, which led to stories that I had never heard. It has been a genuine pleasure to work on this project.

As with any major undertaking, this book did not come about through the efforts of any one person, but of many. People opened their scrapbooks, organizations gave me access to their archives, and I had the opportunity to literally spend hours listening to tales and recollections of Jefferson's past. I wish to thank the following people, in alphabetical order, because they all contributed greatly to this book: Anita Nowell; Ann Tillman; Bobbie Hardy; the Boo Benefit; Cody and Sarah Hughes; Der Basket Kase; Historic Jefferson Foundation; James and Fran Rounds; James Gouldsby; Jefferson Historical Society and Museum; Jefferson's Carnegie Library; Jessie Allen Wise Garden Club; John Nance; Johnson's Ranch Marina, Uncertain, Texas; Kay Avery; Lafayette Street Vintage Car Museum; LSU-Shreveport Archives, Noel Memorial Library; Marion County Chamber of Commerce; Marion County Historical Commission; Marshall and Diana Walla; Mason-Dixon Line Military Exhibition; Michelle Otstott; the Museum of Measurement and Time; Pat Daniel and the Board of the Excelsior Foundation; R.W. Norton Art Gallery, Shreveport, Louisiana; Scarlett O'Hardy's Gone With the Wind Museum; Simone Williams from Arcadia Publishing; Tami Whitington, my wife, editor, critic, and cheerleader; the Old Store and Fudge Shop; Turning Basin Riverboat Tours; and the US Army Corps of Engineers.

INTRODUCTION

Jefferson, Texas, is a town steeped in history and tradition. Where else in East Texas can one see horse-drawn carriages lazily plodding along the streets, residents in 1800s dress walking the paths of the historical district, and soldiers in uniforms from both the Union and Confederacy skirmishing in the alleyways? One can only find this charm in Jefferson, a city that retains the personality and enchantment of bygone days.

Most visitors do not realize that this quaint tourist mecca was once one of the largest cities in the entire state of Texas. It was second only to Galveston in the 1800s and was destined to be a bustling metropolitan area in the current day. Thankfully, a series of events in the late 1800s froze Jefferson in time, leaving it the charming little city with its history and buildings intact today.

Long before settlers established the camps that would grow into a city, the Caddo Indians ruled the region. They used the waterways, including Jefferson's Big Cypress Bayou, as their means of travel and lived a peaceful, prosperous existence.

Later, Spain and France both claimed the area. When the United States acquired it, however, the boundaries that included Caddo Lake and the surrounding countryside were in dispute, transforming it into a no-man's land without rules where outlaws sought refuge and flourished.

Allen Urquhart and Daniel Alley saw promise in a particular tract of land in a bend of the Big Cypress Bayou, and each purchased half of the Stephen Smith land grant. They laid out the city that would be named for Pres. Thomas Jefferson. Rule and order were established, and the city began to grow.

Steamboats traveling up the Red River from New Orleans were seeking passage into Texas, and when a massive logjam, the Great Red River Raft, blocked their way, they took the Big Cypress Bayou across Caddo Lake and followed the river into Jefferson. The first steamboat to arrive was the *Llama*, piloted by Capt. W.W. Withenberry. From that point on, the ships arrived on almost a daily basis, and a trade route was established between Jefferson and New Orleans.

By the mid-1800s, Jefferson had 10,000 to 12,000 residents. That might be insignificant by 21st-century standards, but in those days, it was considered a bustling river port town. It is said that all of the materials that were used to build the smaller cities, such as Dallas and Fort Worth, were shipped through Jefferson.

When the Civil War came, Jefferson played an important part as a shipping point for Confederate supplies. There was a meatpacking plant in town as well as a boot factory, and the black powder manufactured in Marshall, Texas, was stored in Jefferson until it could be sent out to the Southern troops. The Union army, recognizing the importance of the river port, set out to burn it in the Red River Campaign. They were stopped by Confederate forces in Mansfield, Louisiana, and engaged in a battle that saved the homes and buildings of Jefferson from the torch.

By the late 1800s, the Army Corps of Engineers had cleared the Red River Raft. This not only opened up travel northward on the river, but also caused secondary waterways, such as Jefferson's Big Cypress Bayou and Caddo Lake, to fall. Jefferson was no longer accessible by steamship, but

even if it had been, shipping and travel were shifting to the advent of the railway. The city began to fade; the population went from 10,000 to 12,000 down to just a couple of thousand folks, where it has remained ever since. Most people viewed this as the end of Jefferson.

In the 1960s, however, an unlikely group of people arose as the champions of the town. The ladies of the local garden club purchased the decrepit, old Excelsior House Hotel and began to turn it into a showplace. They then opened up their historic homes to the public in an annual tour, and people began to come to Jefferson. More events arose, and historic preservation and restoration became the order of the day. Many of the old homes were turned into bed and breakfast inns, and in 1997, the Texas State Legislature named Jefferson the "Bed and Breakfast Capital of Texas."

It is a town with a wonderful story to tell, and thanks to its residents, that rich history will continue to be shared for generations to come.

One

THE GREAT RED RIVER RAFT

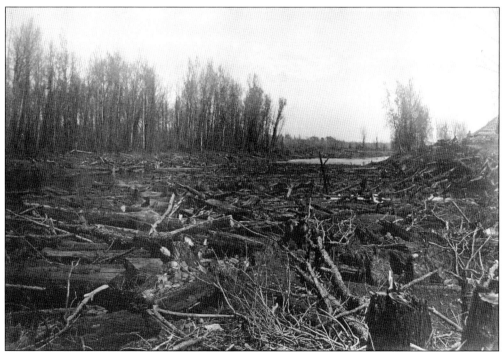

The city of Jefferson got its start not by design or plan, but instead by an incredible act of nature. At one time, scientists believe that the Red River flowed directly to the Gulf of Mexico. There is evidence to support the fact that it cut through the Atchafalaya region of Louisiana thousands of years ago. As rivers tend to do over time, at some point the Red changed course and connected with the Mississippi River. When that happened, the Red began to flood during the rainy season like never before. Trees were washed out of the red, sandy soil on the banks and then fell into the water where they would sometimes snag; slowly, a logjam began to form. (Courtesy LSU-Shreveport Archives, Noel Memorial Library.)

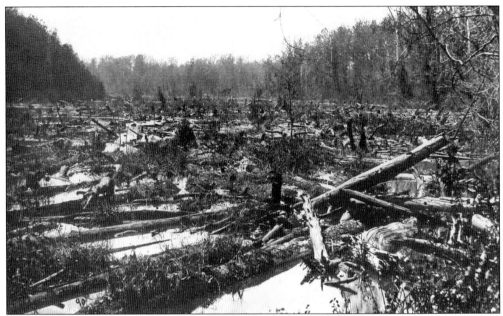

The logjam grew to over 100 miles long, and the logs became so thick that there were places where a rider could cross the river on horseback, as if a natural bridge had been built for that purpose. Other areas had a buildup of dirt on top of the logs that was deposited there by the river, and trees began to actually grow on top of the logjam. (Courtesy LSU-Shreveport Archives, Noel Memorial Library.)

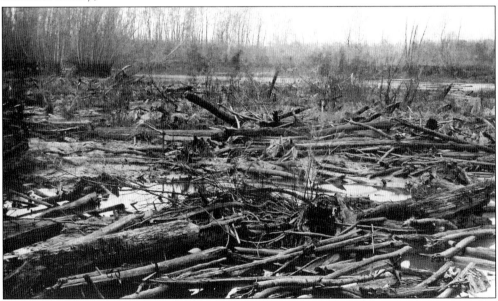

Although the existence of the logjam goes back through Native American history, it was first recorded on paper by European explorers. In 1718, the Company of the Indies commissioned Jean-Baptiste Benard de La Harpe to explore the Louisiana area. He traveled up the Red from Natchitoches and reached "very difficult logjams" on his second day of travel. The natural blockade became known as the Great Red River Raft. (Courtesy LSU-Shreveport Archives, Noel Memorial Library.)

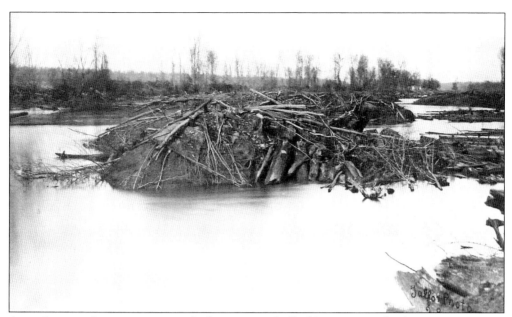

As explorers and entrepreneurs made their way up the Red River in search of new opportunities, they were forced to navigate the narrow passageways and divert their crafts through the network of lakes formed by water flowing away from the logjam. This process could take months, and transportation was impractical. (Courtesy LSU-Shreveport Archives, Noel Memorial Library.)

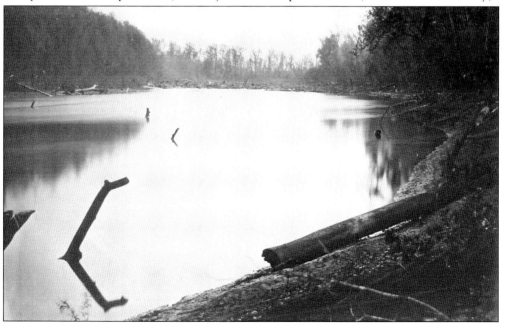

In 1819, W.B. Dewees penned a letter describing the logjam: "I hardly know how to give you a description of this raft, but perhaps you can get the best idea of it by imagining yourself in a large swamp, grown up with trees and filled up with driftwood, wedged in very closely. Sometimes we would come across lakes two or three miles in extent, and then again we would spend a whole day in moving not further than the length of the boat." (Courtesy LSU-Shreveport Archives, Noel Memorial Library.)

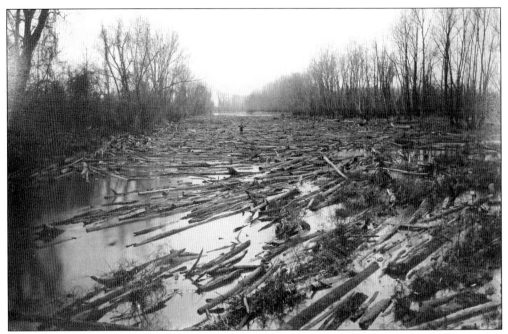

A missionary named Timothy Flint described the raft in the 1820s: "The river is blocked up by this immense mass of timber for a length of between 60 and 70 miles. In places, the whole width of the river may be crossed on horseback, and boats only make their way by following the inlet of a lake, and coasting it to its outlet." (Courtesy LSU-Shreveport Archives, Noel Memorial Library.)

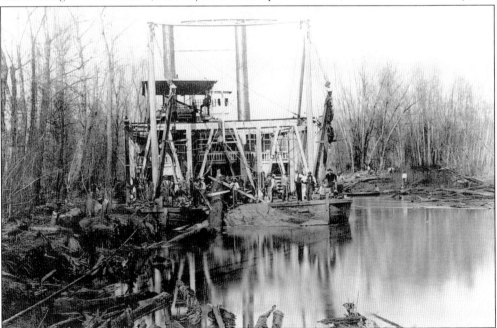

One thing became clear: the Great Red River Raft had to be cleared. This task was started by the Army Corps of Engineers in 1832 and led by the respected river captain Henry Miller Shreve. He employed snag boats, which had high beams and a pulley system that facilitated removing the logs one by one from the Red River Raft. (Author's collection.)

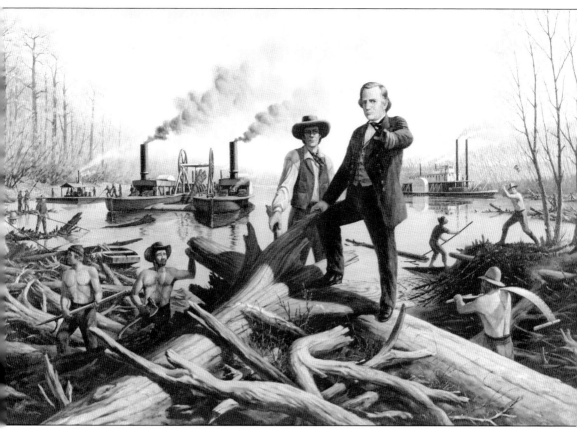

Captain Shreve spent a decade of his life clearing the logjam, and although several others worked on the task, it was finally completed by George Woodruff. Shreve is generally credited with the task. This is shown in the iconic painting by Lloyd Hawthorne, *Captain Henry M. Shreve Clearing the Great Raft from Red River.* (Courtesy R.W. Norton Art Gallery, Shreveport, Louisiana.)

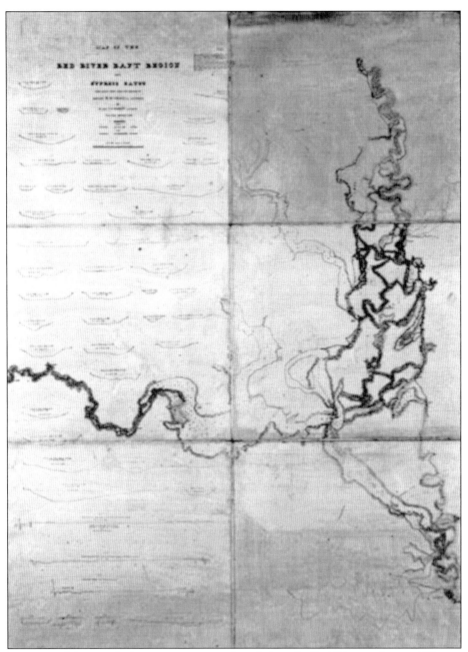

In the course of clearing the logjam, a town was founded on the Red River and named Shreveport in honor of Capt. Henry Miller Shreve. Trade routes were soon established, and steamships laden with cargo and settlers made their way up the cleared river from New Orleans. When the logjam was pushed northward past the confluence with the Big Cypress Bayou, a route into Texas was finally uncovered, and the ships followed the river across Caddo Lake and into the river port city of Jefferson. To facilitate this, the US Army Corps of Engineers published a map showing a survey of the Red River Raft region and Big Cypress Bayou to aid the ship captains in navigating the way into the Lone Star State. Jefferson's stature as a major port city had been established. (Courtesy US Army Corps of Engineers.)

Two

MYSTERIOUS CADDO LAKE

The first inhabitants of the region were the Caddo Indians. Unlike some other North American Indian tribes, the Caddoes were not nomadic. They established villages and enjoyed a peaceful, prosperous existence. They were very adept at farming, hunting, and fishing. In their villages, they grew corn, beans, squash, pumpkins, and sunflowers. As settlers made their way into the area, however, the Caddo were pushed northward and to the east, finally being relocated in Oklahoma. (Courtesy Library of Congress.)

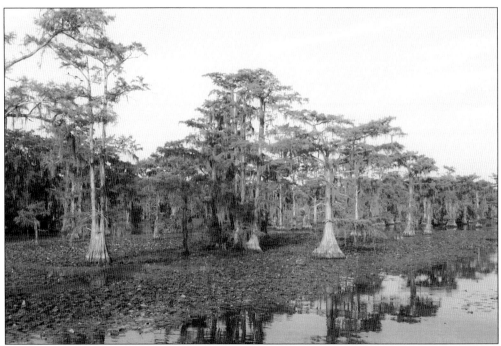

Caddo Lake, named for the tribe, was formed by the Great Raft acting as a dam on the Red River. Cypress trees rise majestically from its waters, their branches draped with Spanish moss like wedding veils. Cypress knolls ring the bases of the trees, adding to the mysterious beauty of the lake. (Courtesy Caddo Lake Steamboat Company.)

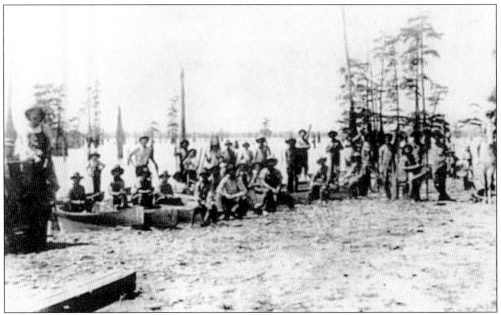

When the logjam was cleared and the lake fell, parts of the lake bed that had never been seen before were revealed, including mussel beds. When freshwater pearls were found in the mussels in 1909, a short-lived pearl-harvesting industry seemed to spring up overnight. Pearl hunters on Caddo Lake are shown in this photograph. (Courtesy Library of Congress.)

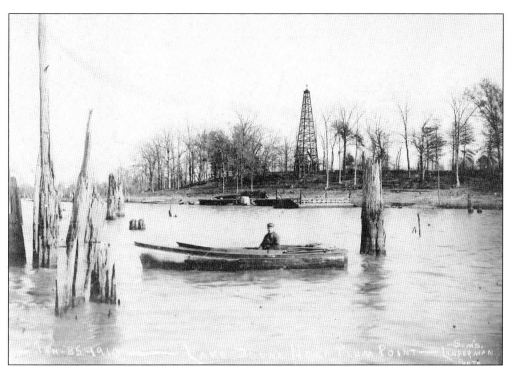

Oil was struck near the lake on March 28, 1905, and the rush was on. Wells were drilled all across the region, and soon, an estimated 25,000 people were working in the industry there. Oil production soared, and it seemed like a new rig was erected every day. When there was no more land to lease, people looked to the 8,000 acres of lake. Oilmen speculated that with the surrounding land as rich as it was, there must be oil under the water as well, so oil rigs soon dotted the landscape of the lake. By the 1960s, oil production had diminished. Although some wells continued to operate, the corporations had turned their attention to other regions. (Both, courtesy Jefferson Historical Society and Museum.)

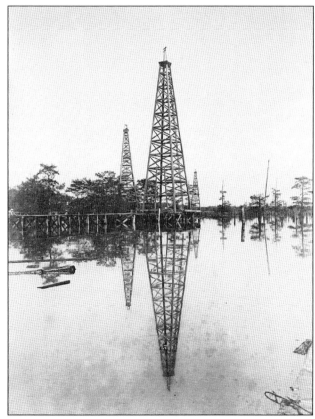

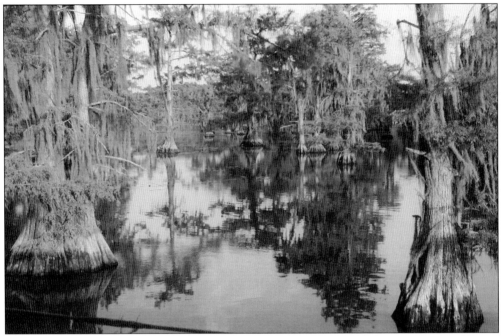

The cypress trees form water roads, passageways with odd names such as Mossy Break, Hog Wallow, Alligator Bayou, Whiskey Slough, and many more. On a typical boat trip, one is likely to see alligators, snapping turtles, a huge variety of waterfowl, and maybe even a gar the size of a man. (Author's collection.)

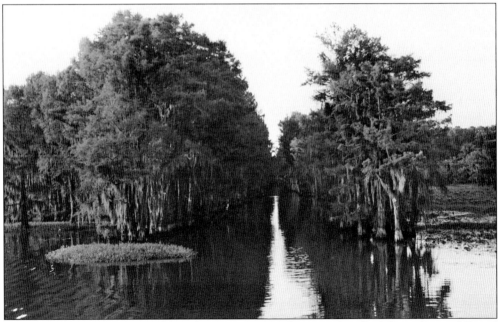

The Government Ditch at Caddo Lake is a remnant of a time after the lake and river fell, and steamships could no longer reach Jefferson. In an attempt to keep the trade route open, the US government used a dredge boat to try to dig a channel through the lake. The project was eventually abandoned, but the passageway still exists today. (Courtesy Caddo Lake Steamboat Company.)

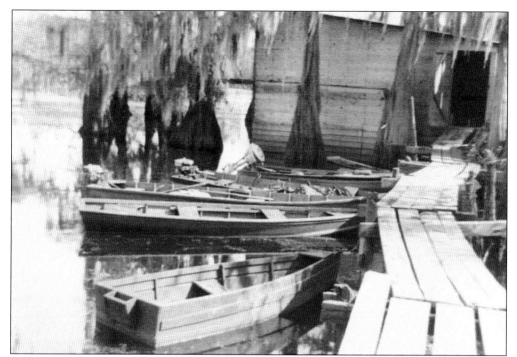

Caddo Lake had a notorious side that developed after Prohibition. Because Texas only permitted alcohol sales in certain counties, Marion County became wet while Harrison County to the south went dry. Residents of the latter discovered that it was legal for them to cross the lake to beer boats docked on the Marion County side for a drink. (Courtesy Johnson's Ranch Marina, Uncertain, Texas.)

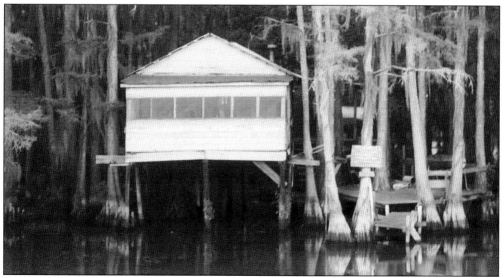

Establishments similar to this building were constructed first on pontoons and later on pylons, meeting the letter of the law and allowing beer to be sold at their establishments as long as the beer boats remained on the Marion County side. The beer industry on Caddo Lake came to a halt when Marion County voted to prohibit the sale of alcohol in 1941. The vote ended one of the most colorful chapters in the history of the lake. (Courtesy Caddo Lake Steamboat Company.)

The lake can be treacherous, however. Its maze of water roads can be confusing to those unfamiliar with the lake, and it is shallow in places. The average depth is only four to five feet, and even on open water, stumps from cypress trees can be hiding just below the surface. (Courtesy Caddo Lake Steamboat Company.)

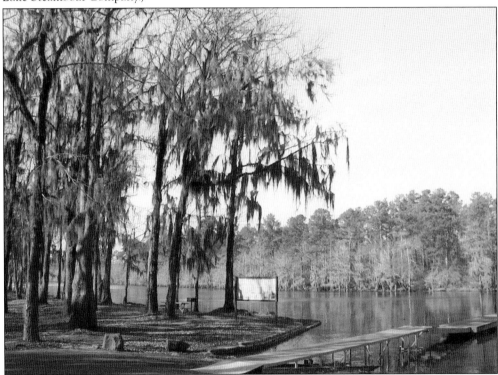

Even with its dangers, many consider Caddo to be one of the most beautiful lakes in the country. Today, it is a 26,000-acre lake populated with 400-year-old bald cypress trees draped with Spanish moss. It is heaven for fishermen, who routinely pull trophy-size bass, crappie, bluegill, and catfish from its waters. (Courtesy Caddo Lake Steamboat Company.)

Three

THE STEAMBOAT AGE

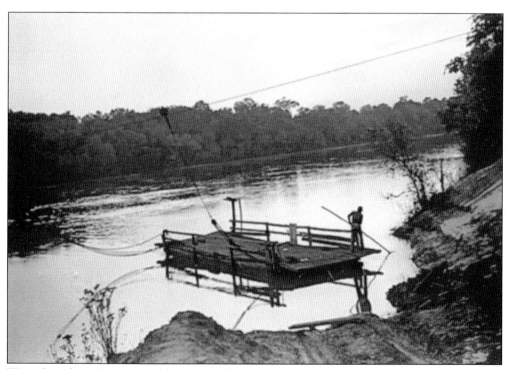

Water has always been the lifeblood of Jefferson. The area that eventually became the city was originally a river crossing, where a cable ferry operated by Allen Urquhart carried travelers across for a fee. As the number of people increased, Urquhart saw the potential for a town at the location and purchased 640 acres. Soon, Daniel Alley bought the adjoining tract, and a town named for Thomas Jefferson began to grow. (Courtesy Library of Congress.)

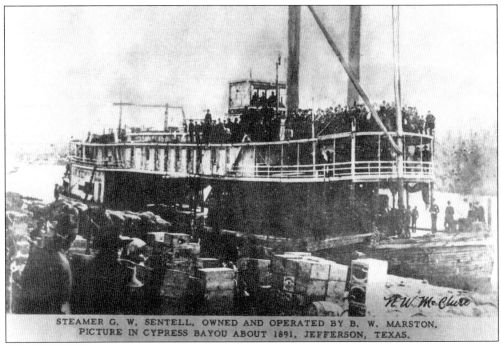

STEAMER G. W. SENTELL, OWNED AND OPERATED BY B. W. MARSTON.
PICTURE IN CYPRESS BAYOU ABOUT 1891, JEFFERSON, TEXAS.

Steamships seeking a route into Texas began to make their way to the town, bringing travelers and freight. These ships would navigate the Mississippi and Red Rivers with New Orleans and Jefferson as the endpoints of the route. The large steamship G.W. *Sentell* is shown docked in town. (Courtesy the Old Store and Fudge Shop.)

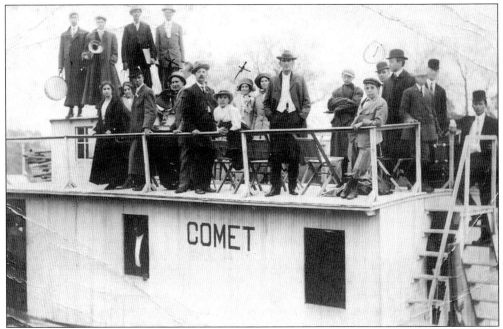

Smaller traveling ships such as the *Comet* were known for their passenger accommodations. The top deck of this ship has seating for a concert, and the four-piece band is standing atop the wheelhouse. (Courtesy Jefferson Carnegie Library.)

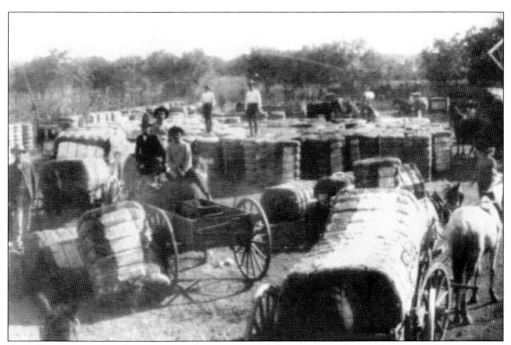

As Jefferson grew as a shipping port, farmers around the region took note. In the 1800s, cotton was king in East Texas; it was the number one cash crop. Growers bailed their cotton and brought it into the city to ship out on the steamships. (Courtesy Jefferson Historical Society and Museum.)

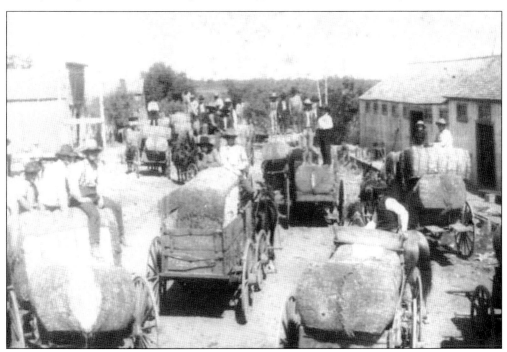

Because of the sheer volume of cotton being brought into town, warehousing became a secondary industry. Some Jefferson buildings that were originally constructed as warehouses are now restaurants, hotels, and stores. (Courtesy Jefferson Historical Society and Museum.)

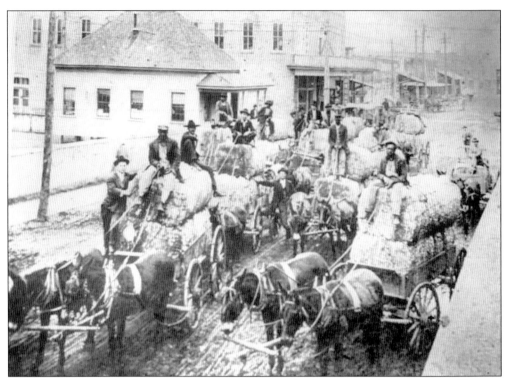

Mule-drawn wagons hauling cotton were a common sight downtown, often causing traffic jams such as this one on Lafayette Street. Men hired out their teams of mules and wagons to transport cotton bales for a fee—such entrepreneurs were called teamsters. (Courtesy Jefferson Historical Society and Museum.)

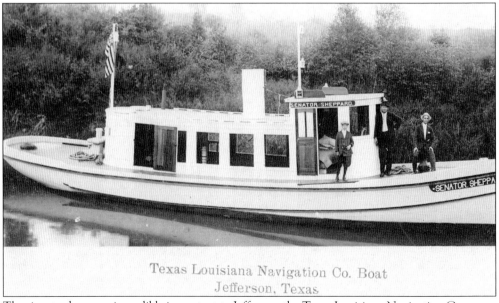

The river trade was so incredibly important to Jefferson, the Texas Louisiana Navigation Company was established to facilitate travel on the waterways and insure that an open route existed between Jefferson, Mooringsport, and Shreveport. (Courtesy Jefferson Historical Society and Museum.)

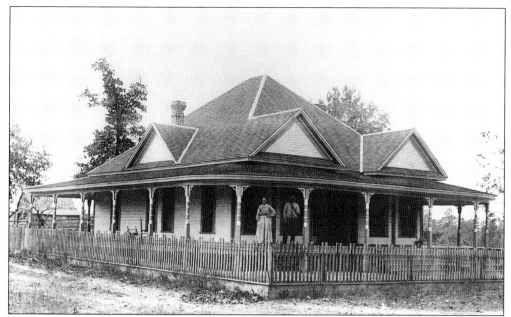

As commerce brought growth to the city, people began to lay down roots. The initial temporary buildings that went up were replaced by beautiful homes like the one shown here, located at the corner of Market and Lafayette Streets. (Courtesy Jefferson Historical Society and Museum.)

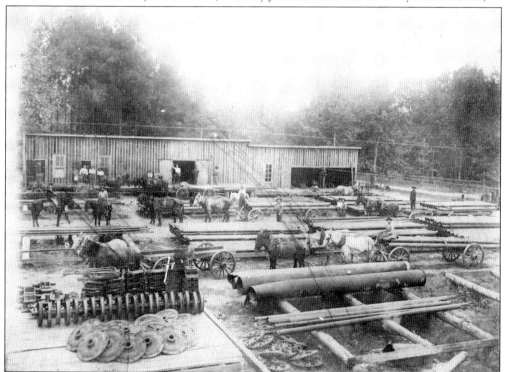

It is said that prosperity breeds prosperity; such was the case in Jefferson. With new homes and buildings being constructed, there was an explosive need for lumber. Sawmills sprung up around the area to address this problem. (Courtesy Jefferson Historical Society and Museum.)

Of course, the piney forest of East Texas was the perfect setting for this industry. Landowners sold their timber resources, sawmills employed workers, lumber was purchased and then sold by merchants, and Jefferson prospered. (Courtesy Jefferson Historical Society and Museum.)

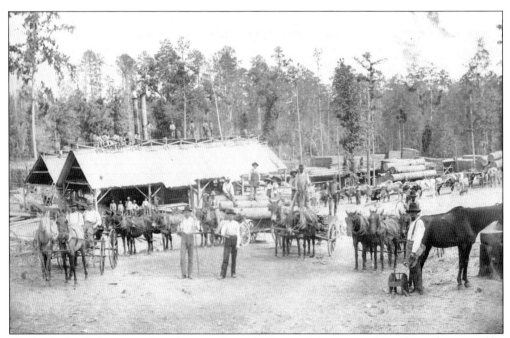

The lumbering industry continued to grow beyond Jefferson. The cut wood was shipped westward by mule and sold to other developing cities. It is said that the wood that was used to build Dallas and Fort Worth was shipped from Jefferson. (Courtesy Jefferson Historical Society and Museum.)

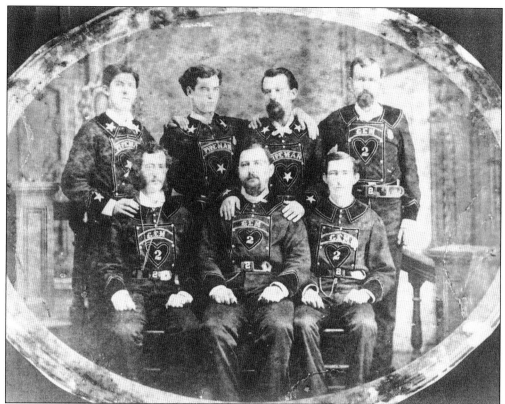

With the town's growth came all the trappings of a modern city of its day, including a fire department—a necessity in a town with so many warehouses stacked with bales of cotton. Fire, nevertheless, roared through the blocks of town on several occasions, but each time was put into check by the men of the fire department. (Courtesy Jefferson Historical Society and Museum.)

When the Civil War broke out, men from Jefferson rose to the cause. Soldiers such as the ones shown here were mustered into service, many to serve in Hill's Texas Brigade. (Courtesy Jefferson Historical Society and Museum.)

Jefferson itself was spared the ravages of war when the Union troops who were approaching lost the Battle of Mansfield in Louisiana. The war ended, and the citizens went back to their genteel activities. In this image, some local young people enjoy a picnic during peacetime. (Courtesy Jefferson Historical Society and Museum.)

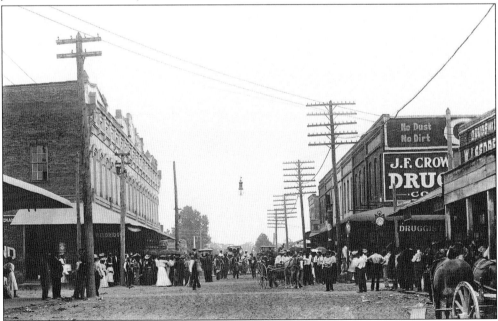

As the Red River Raft was cleared, Caddo Lake and the Big Cypress Bayou began to fall. It became increasingly difficult for steamships to navigate the waterways that once were lifelines to Jefferson. The town began to falter, people moved away and businesses closed, and even with bustling trade days, such as the one depicted here, people began to feel that the end of Jefferson was at hand. (Courtesy Jefferson Historical Society and Museum.)

Four

AFTER THE STEAMSHIPS

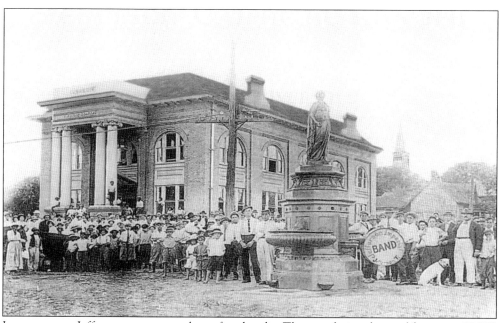

In many ways, Jefferson was a town that refused to die. The population dropped from over 10,000 people to just 2,000, but the spirit of the people left remained strong. In 1913, the Sterne family donated a fountain to the city, located on Lafayette Street by the Carnegie Library and topped by a statue of the goddess Hebe—the entire town turned out for the dedication ceremony. (Courtesy Jefferson Historical Society and Museum.)

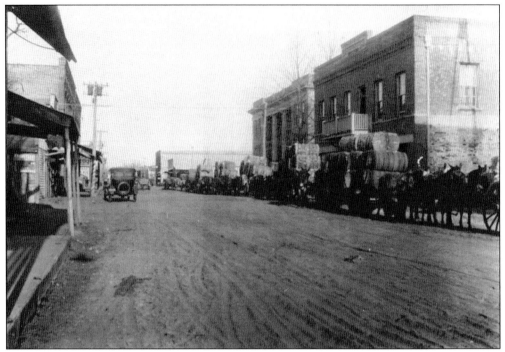

The cotton trade suffered without the steamships, and farmers were forced to rely more heavily on the teamsters to deliver their bales to cities with railroad depots; fortunately, the rail was not far out of Jefferson's future. In this photograph, mule-drawn wagons are loaded with cotton and lined up along Austin Street. (Courtesy Jefferson Historical Society and Museum.)

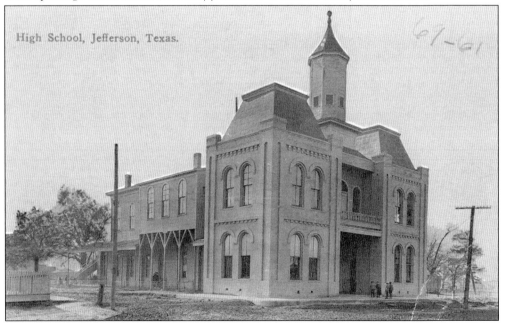

A high school was constructed on Jefferson Street between Main and Line Streets on a town square that had served as a farmer's market. It was two stories high with a bell tower and considered very modern by all of the standards of the day. (Author's collection.)

Marion County was once a part of Cass County to the north, but 420 square miles were demarked from Cass by an act of the state legislature on February 8, 1860. Territorial additions in 1863 and 1874 extended its southern boundary to include both banks of Big Cypress Bayou. The new county that was formed was named for Gen. Francis Marion, a Revolutionary War officer known as the "Swamp Fox." A courthouse was built to serve the county on the western side of town. (Courtesy Jefferson Historical Society and Museum.)

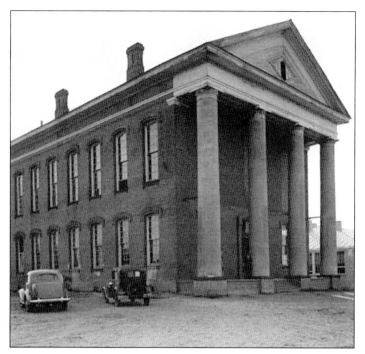

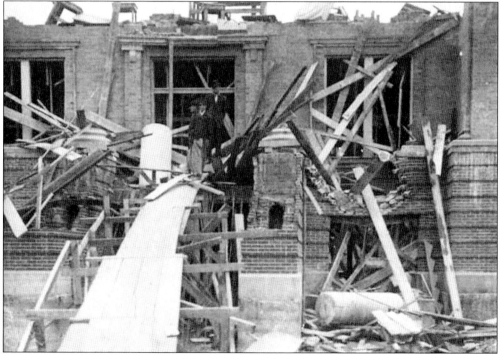

It was eventually decided that a larger courthouse was needed and that this one should be located downtown in the business district. The new courthouse was designed in the Classical Revival style by architect Elmer George Withers and constructed by L.R. Wright and O.L. Hitchcock in 1912. Construction was interrupted by a tornado that touched down in Jefferson. (Courtesy Jefferson Carnegie Library.)

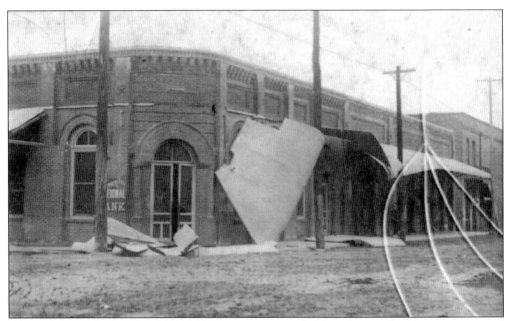

The 1911 tornado tore through the downtown area, and although most buildings were spared structural damage, businesses such as the Commercial National Bank, shown here, were forced to make cosmetic repairs. (Courtesy Jefferson Carnegie Library.)

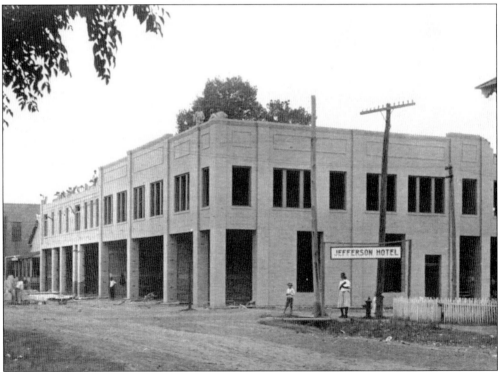

Less fortunate were the buildings that were under construction when the tornado hit, such as this office structure at the corner of Lafayette and Vale Streets. The high winds and whirling debris smashed windows and tore down scaffolding. (Courtesy Jefferson Carnegie Library.)

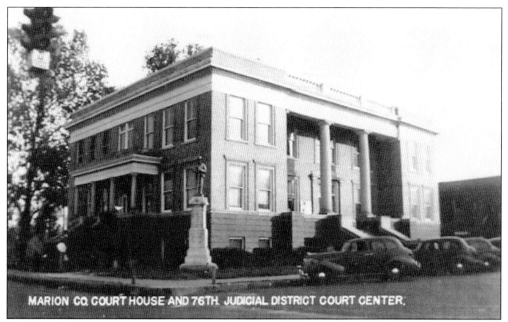

MARION CO. COURT HOUSE AND 76TH. JUDICIAL DISTRICT COURT CENTER.

In spite of the hurricane, occasional floods, and the natural delays that are part of any project, the new courthouse opened. A statue honoring Jefferson's Confederate war dead was moved from the north of town to the northern corner of the building. (Author's collection.)

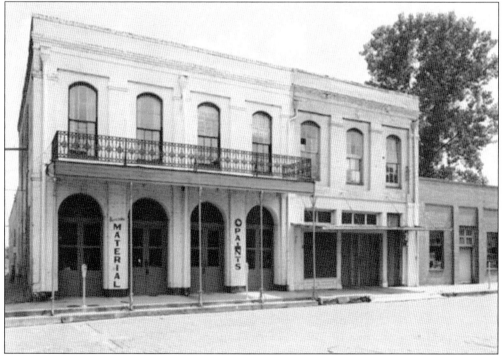

While it did not experience the growth of the 1800s, Jefferson continued to survive. Business came and went with the times. The Planters Bank building on Austin and Walnut Streets, constructed in 1852, was used as a riverfront warehouse during Jefferson's heyday. After the steamship era, it became a hardware store, as seen in this photograph. (Courtesy Jefferson Carnegie Library.)

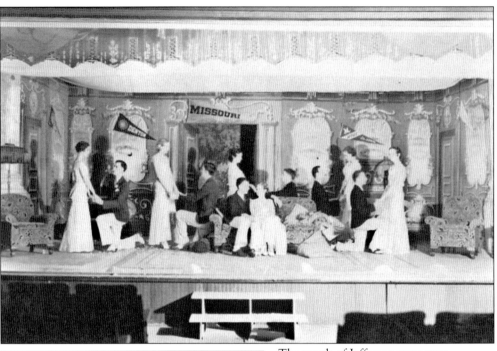

The youth of Jefferson were very involved with the city's rich past, and the high school boasted organizations such as the Jefferson Junior Historians who focused on the study and preservation of the town. The school also focused on the arts, as demonstrated by this photograph and program from a senior class production of the play *The Collegiates* in 1932. (Both, courtesy Jefferson Carnegie Library.)

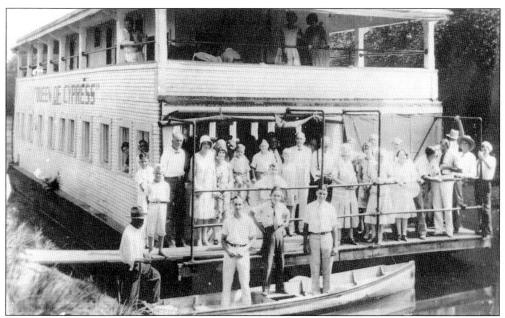

When the Great Depression hit, the people of Jefferson looked for affordable entertainment. The *Queen of Cypress* was a venue for dancing and dining as it cruised up and down the bayou. It is shown here with a group of passengers. (Courtesy Jefferson Historical Society and Museum.)

A popular spot for children of Jefferson was the Corral Swimming Hole on Big Cypress Bayou. Legend states that in bygone years, Indians would put rocks on either side of the rounded bend in the river and ride their wild horses in to break them, much as cowboys would do in a fenced corral. The kids divided the time—the boys had a certain period where they could swim and then the girls took over. A lookout was always posted, however, since swimming was done sans suits. (Courtesy Jefferson Carnegie Library.)

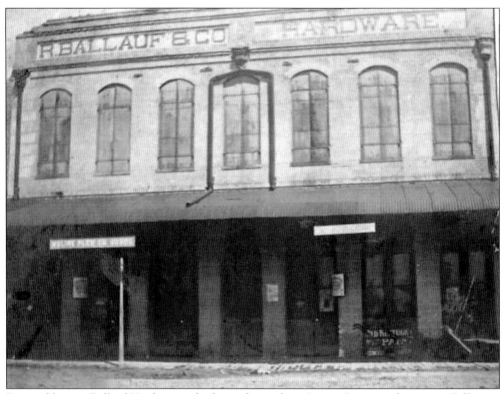

Pictured here is Ballauf Hardware, which was located on Austin Street in downtown Jefferson. Rudolph Ballauf, a German immigrant, started the business after moving to Jefferson from New Orleans in 1867. (Courtesy Jefferson Carnegie Library.)

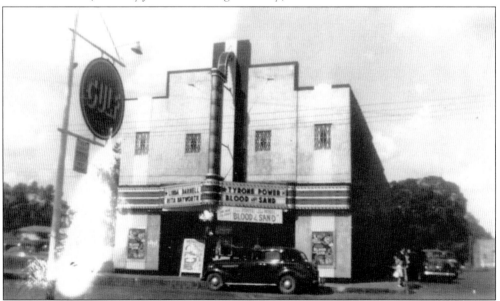

The Strand Theater was the center of entertainment and culture in Jefferson, bringing films from the latest stars like Tyrone Power, as shown in this 1933 photograph boasting the movie *Blood and Sand*. (Courtesy Jefferson Carnegie Library.)

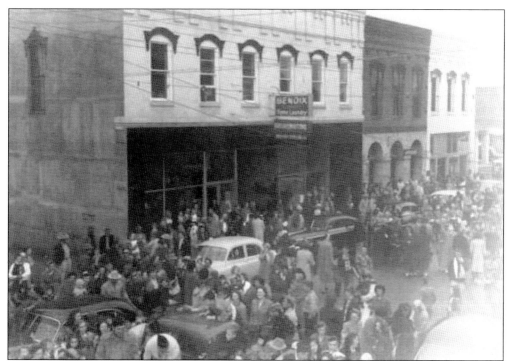

Celebrations have always been a part of Jefferson's past, from the days when revelers came up the river, dancing and dining on the steamships. Shown here is a parade on Austin Street in front of Haggard Furniture and Appliance, near the corner of Austin and Polk Streets. Everyone is having such a good time that it is difficult to tell where the parade ends and the spectators begin. (Courtesy Jefferson Carnegie Library.)

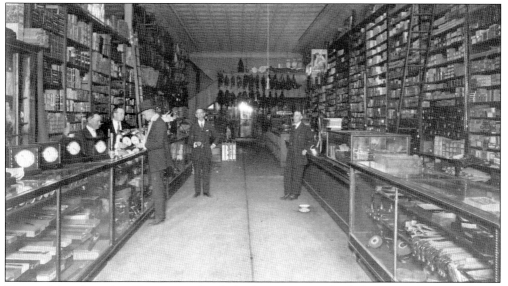

Torrans Manufacturing Company, a family business, soon realized that operating a retail store would be a more lucrative proposition than a wholesale manufacturing business. The Torrans family opened a hardware store in downtown Jefferson, shown here in 1920. (Courtesy Jefferson Historical Society and Museum.)

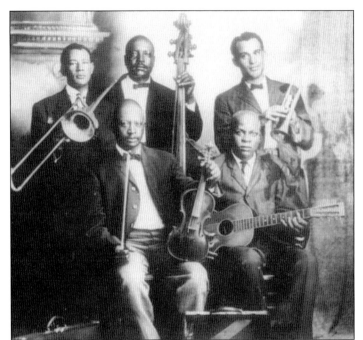

A cornerstone of Jefferson culture was Hamp Walker's String Band. The ensemble played dances, parties, and any other soirees around Jefferson. It was said that a social event was not a true social event unless Walker and his bandsmen were there. (Courtesy Jefferson Historical Society and Museum.)

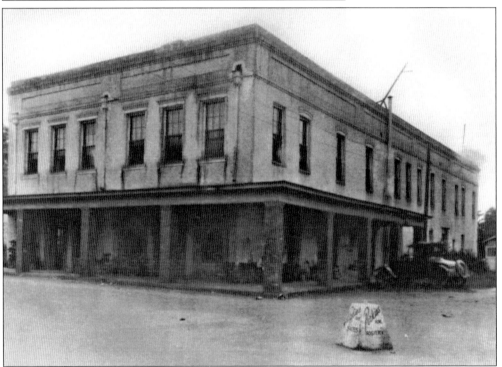

After its beginnings as a cotton warehouse, a number of businesses occupied this building at the corner of Austin and Vale Streets before it finally became the historic Jefferson Hotel. Local legend hints that during rowdier times, the restaurant there was once a dance hall and the ladies of the evening would rendezvous with gentlemen there, leading them upstairs where they had rented rooms in which to conduct business. (Courtesy Jefferson Carnegie Library.)

The Kahn Saloon building was constructed in the 1860s and served as a boardinghouse and then a mercantile before becoming a saloon around 1900. It has a notorious past; not only did the Ku Klux Klan reportedly meet there, but prohibitionist Carrie Nation once came to the saloon to hold an anti-alcohol rally. As the story goes, the bartender barred the door so that she could not enter. (Courtesy Jefferson Historical Society and Museum.)

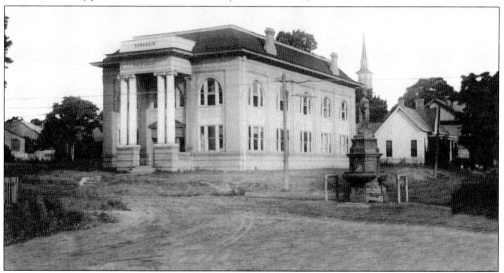

Soon after the turn of the century, Jefferson applied to the Carnegie Foundation for a grant to build a library. On April 15, 1907, a bid was accepted from contractor J.F. Berry of Morris County to build the new library at a cost of $8,750. Locally raised funds added to the grant from Andrew Carnegie made one of the cornerstones of Jefferson's culture and history possible—its public library. When it first opened, the bottom floor was used to house the book collection and the upstairs was a meeting room that was first known as the Auditorium but was eventually dubbed the Old Opera House. (Courtesy Jefferson Carnegie Library.)

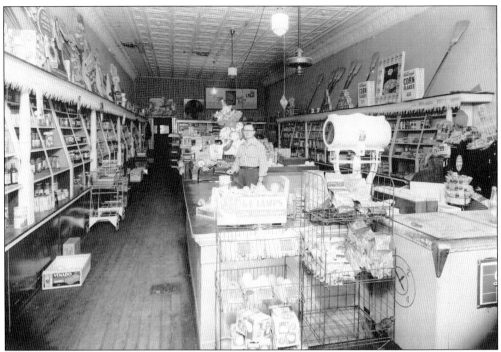

A typical grocery in downtown Jefferson featured not only dry goods on shelves along the sidewalls, but also a scale by the front register and an ice case at the front of the store for cold goods. The architecture of this store is also interesting, with tin square ceilings and ceiling fans that were actually functional, not decorative. (Courtesy Jefferson Historical Society and Museum.)

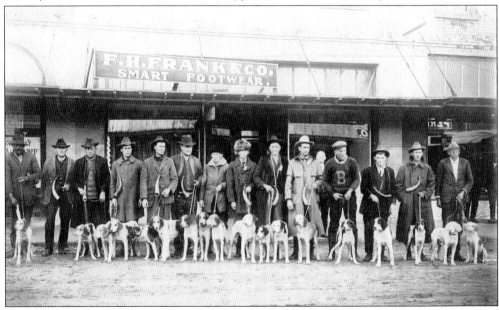

Game hunting evolved from a necessary method of feeding a family in the 1800s to more of a sport in the 1900s. Here, a group of men and their hunting dogs are lined up in front of F.H. Frank's shoe store. Note the horns around each of the dogs' necks. (Courtesy Jefferson Historical Society and Museum.)

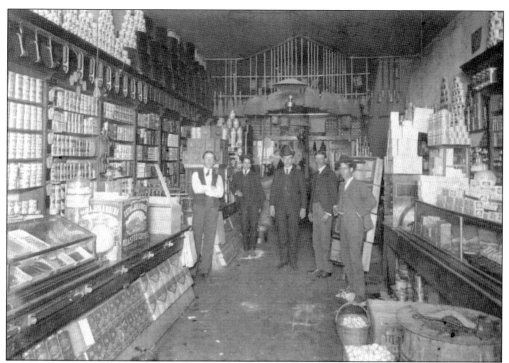

This downtown Jefferson dry goods store has stacks of canned items displayed in pyramid fashion. The owner and clerks are dressed in formal attire, as any respectable businessmen of the day would be. (Courtesy Jefferson Historical Society and Museum.)

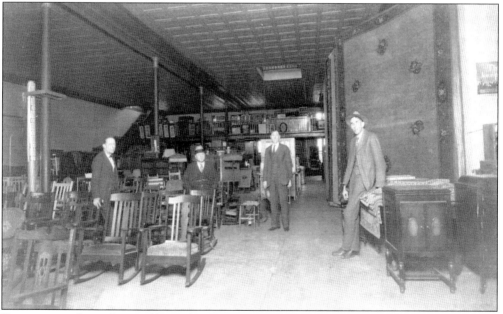

Furniture was shipped into Jefferson from as far away as New York during an age when handcrafted goods were being replaced by items produced in factories for the masses. This is illustrated in the replicated rocking chairs in this furniture store. (Courtesy Jefferson Historical Society and Museum.)

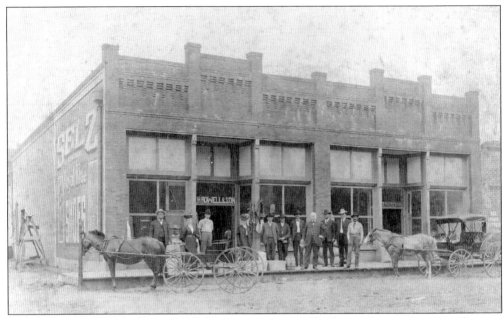

In this photograph of the H. Rowell & Son store are some of Jefferson's businessmen standing out front and two proper horse and buggies waiting for their owners. The prim and proper buggies are quite a departure from the industrial delivery wagons shown in other images in this book and are clearly meant for genteel purposes. Note the advertising painted on the side of the building, which was very common in the day. (Courtesy Jefferson Historical Society and Museum.)

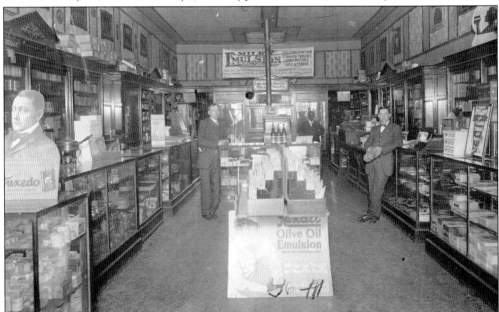

This image shows the interior of the Crow Drug Store, located in downtown Jefferson. Owner J.T. Crow is pictured on the left in the rear with one of his employees on the right and an unidentified man in the back. Note the stovepipe rising to the ceiling in the back center of the store—the stove was the only source of heat during the cold winter months. (Courtesy Jefferson Historical Society and Museum.)

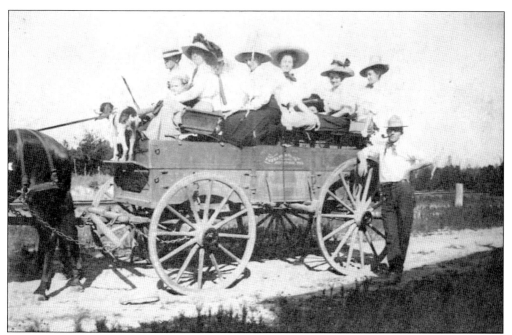

The Torrans Manufacturing delivery wagon served a dual purpose: during the week, it was used in business, but on off days, it could be readily employed for a country outing for the ladies. (Courtesy Jefferson Carnegie Library.)

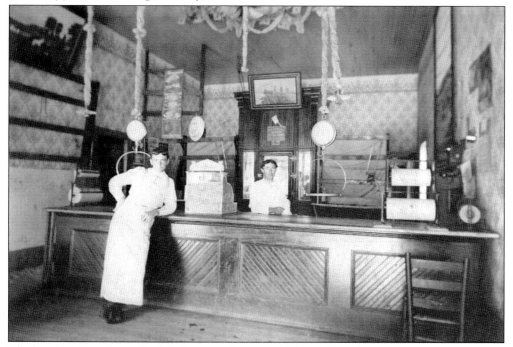

The butcher shop shown in this photograph is very different from the meat counters in present-day supermarkets. In place of today's refrigerated units and display cases are ice-cooled boxes for meat storage. A customer would walk in, order a particular item, and the butcher would go back to the cooler and retrieve it. (Courtesy Jefferson Historical Society and Museum.)

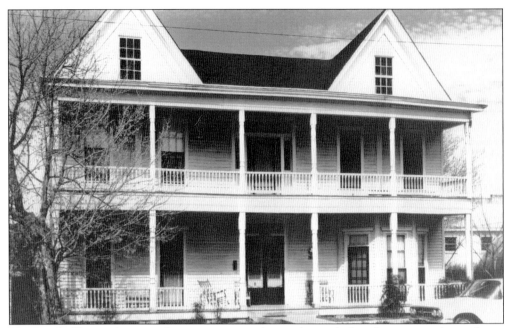

The Brooks House, shown in this image captured several years before the structure burned, was a hotel and boardinghouse on Vale Street. Abe Rothschild and Annie "Diamond Bessie" Moore signed in for a stay as "A. Monroe and wife" in this location. Moore was later found murdered just south of town, and Rothschild was brought to trial in proceedings that became a media circus. He was acquitted on appeal. (Courtesy Jefferson Historical Society and Museum.)

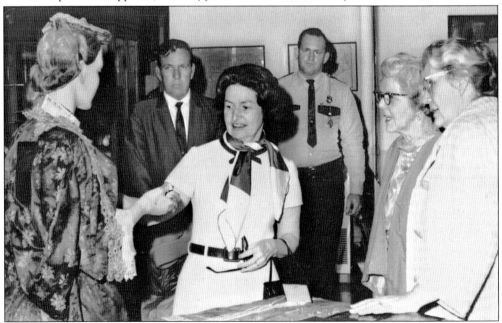

Pres. Lyndon Johnson's wife, Claudia "Lady Bird" Johnson, lived in nearby Karnack but moved to Jefferson to attend school. Her love for the city never waned, and she always loved to return for a visit. Items relating to the first lady are on display at the Jefferson Historical Society and Museum as well as the Excelsior House Hotel.

Five

A Tale of a Garden Club

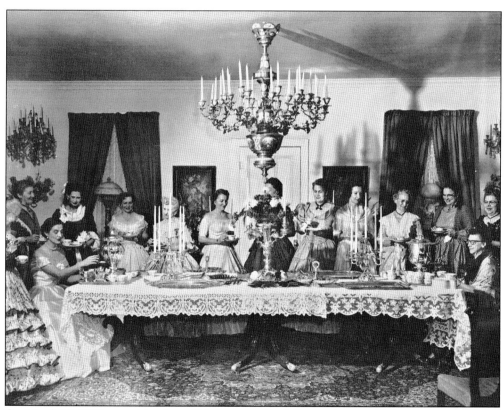

On March 16, 1939, something incredible happened in Jefferson that would change the very future of the city. Thirty-five ladies decided to start a garden club to promote beautification of the town. The ladies shared a vision of bringing culture to the town with flower shows and wildflower tours, so they organized a garden club and named it after Jessie Allen Wise, a beloved civic-minded lady who had passed away a year before. (Courtesy Jessie Allen Wise Garden Club.)

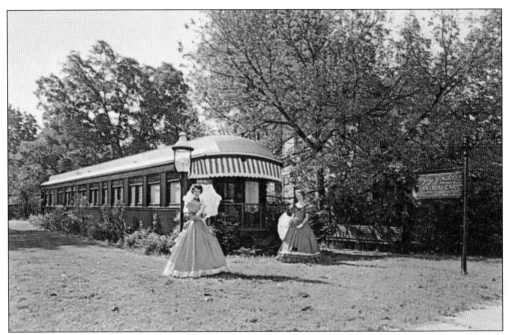

Local legend purports that railroad baron Jay Gould once came to town and attempted to sell the idea of marrying his railroads to the steamship trade to the town fathers. His offer was refused, and Gould cursed the city before leaving. The Jessie Allen Wise Garden Club got the last laugh for Jefferson, however, when they purchased Gould's luxurious private railroad car, restored it, and opened it for tours. (Author's collection.)

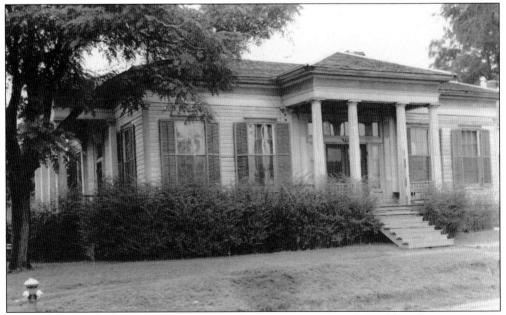

For their next project, the Jessie Allen Wise Garden Club purchased the old Presbyterian manse at the corner of Delta and Alley Streets for $6,000 and lovingly restored it. By 1961, the house had been restored as a showplace and was used as the club's meeting location for almost a decade. (Courtesy Jessie Allen Wise Garden Club.)

Soon, the Jessie Allen Wise Garden Club purchased the Excelsior House Hotel, which was greatly in need of repair. Each member was responsible for restoring and decorating a single room. The doors remained open during the renovation, maintaining the title of the "second oldest operating hotel west of the Mississippi River." When the dust settled, Excelsior House Hotel was reborn into the beautiful, well-appointed hotel that has remained a cornerstone of Jefferson. (Both, courtesy Jessie Allen Wise Garden Club.)

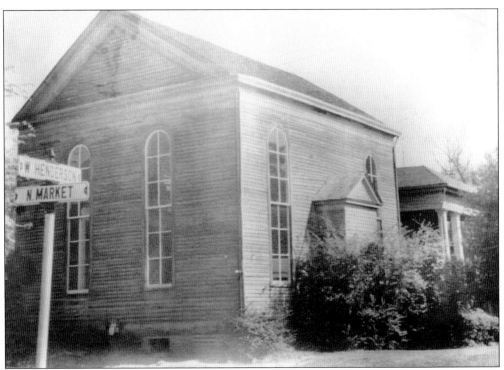

The next project for the Jessie Allen Wise Garden Club was the old Jewish synagogue and the attached rabbi's house, which was later a Catholic school, hospital, and convent. The building eventually fell into disrepair and was destined to disappear into history until the ladies of the Jessie Allen Wise Garden Club stepped in. (Courtesy Jessie Allen Wise Garden Club.)

When the preservation efforts were complete, the former synagogue became a playhouse that is home to the Jessie Allen Wise Garden Club's annual *Diamond Bessie Murder Trial* play and other productions of the Excelsior Players. The rooms in the rabbi's home are now available as an extension of the Excelsior House Hotel, where visitors can enjoy the plush accommodations. (Author's collection.)

Another annual event produced by the Jessie Allen Wise Garden Club was the Dogwood Trail, where visitors were invited to come to Jefferson to view the beautiful blooming trees. One year, the flowers were late, and the ladies scrambled to find something for their guests to do. Several owners of the old, historic homes opened their houses to the public; the event was such a success that the annual Pilgrimage Home Tour was born. Every year since, four of Jefferson's stately houses are decorated with fresh flowers and docents in period costume are ready to share the history with visitors. The event also includes the *Diamond Bessie Murder Trial* play, arts and crafts displays, the Pilgrimage Parade featuring antebellum costumes and Civil War reenactors, and an heirloom plant sale. (Both, courtesy Jessie Allen Wise Garden Club.)

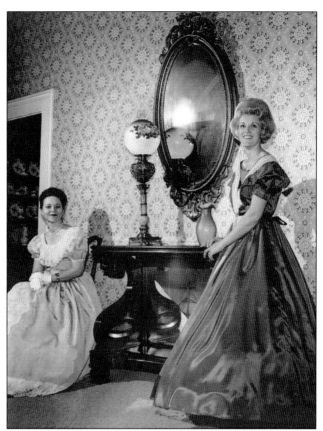

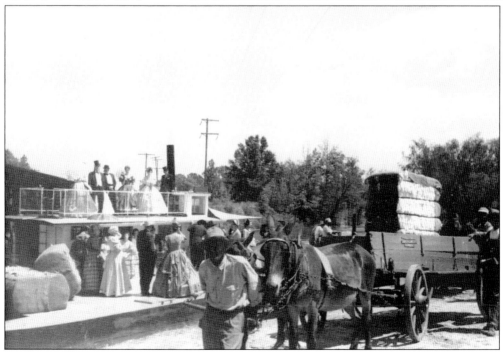

49

Each year, the Pilgrimage Parade forms at Lions Club Park, as shown in this photograph with the Cumberland Presbyterian Church in the background. The grand marshal for this parade was Jessie Allen Wise Garden Club member Mary Lou Ford, who also had the Garden of the Year. (Courtesy Jessie Allen Wise Garden Club.)

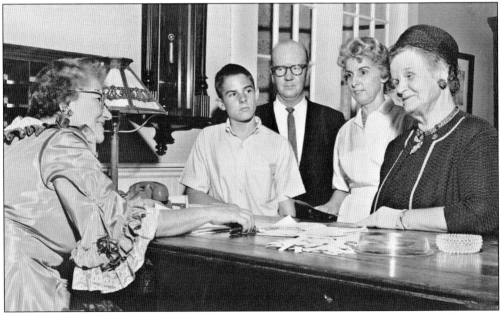

The Excelsior House Hotel has welcomed many distinguished guests over the years, including Pres. Ulysses S. Grant, poet and playwright Oscar Wilde, Lady Bird Johnson, and the 19th president of the United States, Rutherford B. Hayes. In this image, descendants of Capt. William Perry are greeted at the front desk. Perry was a Jefferson pioneer who built part of the structure that is now the Excelsior House Hotel. (Courtesy Jessie Allen Wise Garden Club.)

Six

THE EASTER FLOOD OF 1945

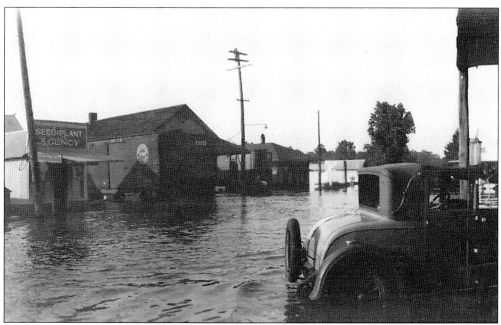

Flooding had been a problem for the city of Jefferson since its founding. When the waters of the Big Cypress Bayou rose, it was often catastrophic for the town. In 1908, sudden rains brought flooding that washed out bridges and trestles and over 100 train passengers were stranded in Jefferson until the waters receded three days later. Periodic flooding continued, and in 1937, a good part of western Marion County was underwater, roads were impassible, and school had to be cancelled because buses were unable to run their routes. (Courtesy the Old Store and Fudge Shop.)

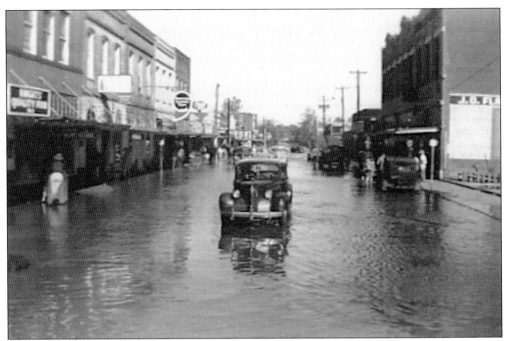

The situation finally grew to be too much for the town. On Easter Sunday, April 2, 1945, the citizens of Jefferson awoke to find that a good part of the city had flooded. Some areas were 6 to 12 inches underwater, while others were submerged over two feet. (Courtesy Der Basket Kase.)

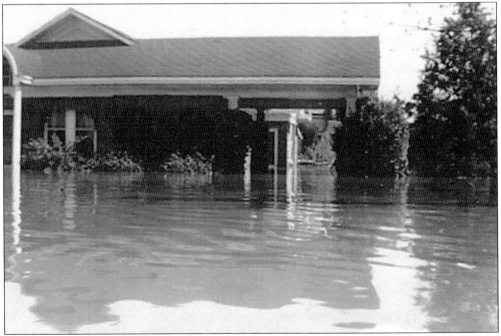

Homeowners scrambled to empty lower cabinets and move their possessions above the waterline. The flood came with little warning, so almost no advance preparations could be made or precautions taken. Attendance at Easter Sunday services was minimal; instead, people manned their fishing boats and went about checking on their neighbors. (Courtesy Der Basket Kase.)

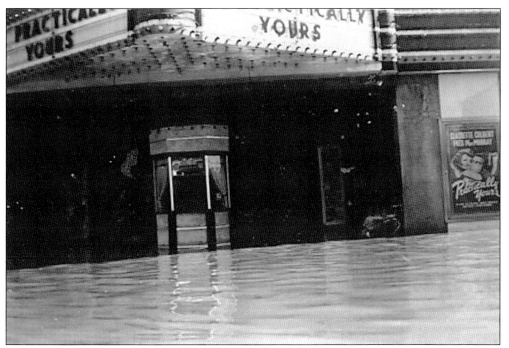

The Strand Theater had been playing the movie *Practically Yours* starring Claudette Colbert, Fred MacMurray, Gil Lamb, and Cecil Kellaway. Floodwaters rushed into the downward-sloping theater, forming a large pond inside. It is said that a few enterprising young men rowed their boats inside and floated around on "Lake Strand." (Courtesy Der Basket Kase.)

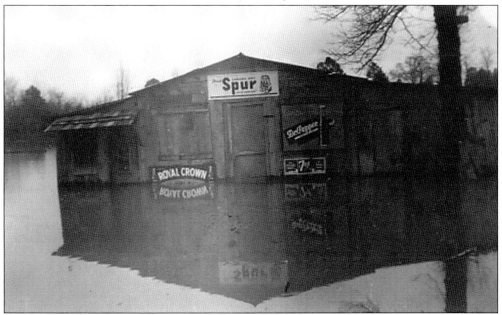

Businesses began to survey the damage—not only did they lose any inventory that was on or near the ground, but the waters made it impossible for shopkeepers to open their doors for business. As the destruction was assessed, a collective sigh passed through the town when it was determined that there had been no serious injury. (Courtesy Der Basket Kase.)

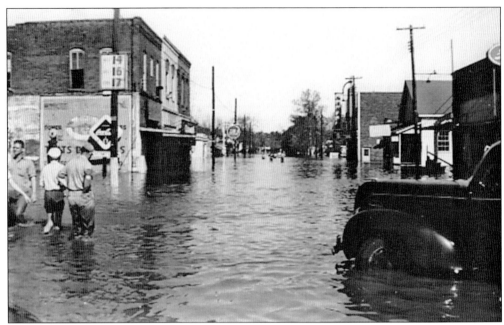

Although the streets were still underwater and the material loss was great, the relief at the lack of human injury brought joy to the town. The Easter Parade that had been scheduled for Sunday afternoon had initially been cancelled, but it was quickly reorganized. Instead of the planned affair, the parade consisted of people in boats, citizens wading knee deep, and automobiles that were willing to brave the waters. (Courtesy Der Basket Kase.)

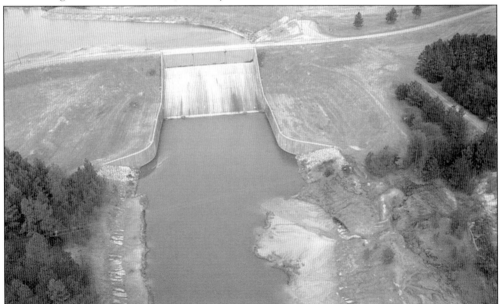

After the Easter Sunday flood of 1945, the citizens demanded action to prevent future flooding. The *Jimplecute* newspaper ran editorials, and people wrote letters to the authorities and representatives. In only 16 months, the Flood Control Act of July 1946 was established. A dam would be constructed to form a lake west of Jefferson, and the Big Cypress would finally be tamed. (Courtesy US Army Corps of Engineers.)

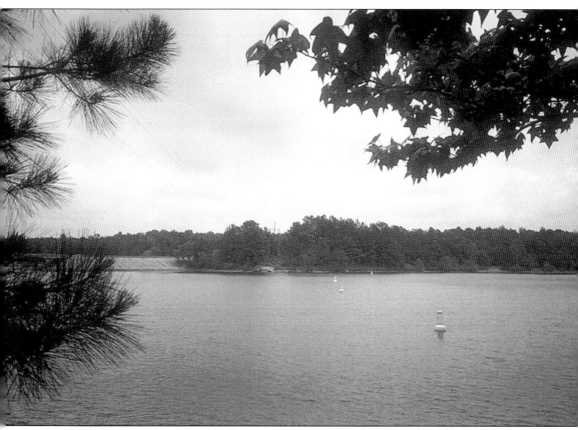

Lake O' the Pines was created as part of the Flood Control Act, and everything was completed on December 11, 1959. Today, the lake is the legacy of the 1945 flood. It is truly beautiful, a sportsman's paradise, with boating, waterskiing, and world-class fishing. (Courtesy US Army Corps of Engineers.)

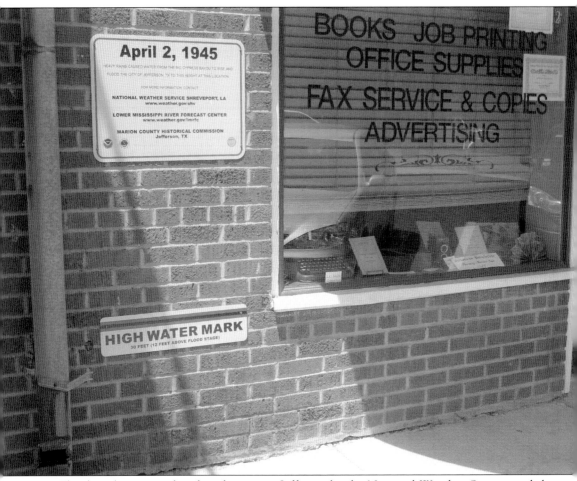

Flood markers were placed in downtown Jefferson by the National Weather Service and the Marion County Historical Commission to commemorate the flood. The high-water mark of different locations is displayed as a reminder of that final flooding the city experienced. (Author's collection.)

Seven

JAY GOULD'S LEGENDARY CURSE

There is one integral tale from Jefferson's past that could be true or false. No one knows for sure, and the arguments and discussions continue to this day. As the story goes, railroad baron Jay Gould visited Jefferson to try and convince the city to allow him to marry his network of railroads to the steamship there. The citizens could not imagine that the railroad could ever replace the steamships, so they denied his request. Gould reportedly walked outside, shook his fist in the air, and proclaimed of Jefferson, "Grass would grow in the streets, and bats would roost in the belfries." (Courtesy the Library of Congress.)

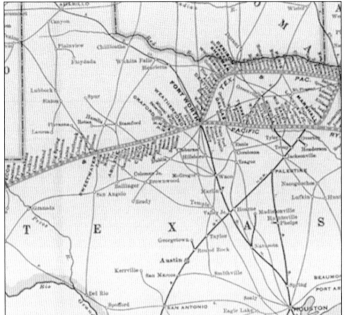

Most railroad historians do not believe that the Gould event actually happened. The Texas and Pacific Railway Company (more commonly known as the T&P) was created by a federal charter in 1871 with the purpose of building a rail connection between Marshall, Texas, and San Diego, California. As shown on this map, Jefferson was simply a stop on the route among many others. (Courtesy Jefferson Historical Society and Museum.)

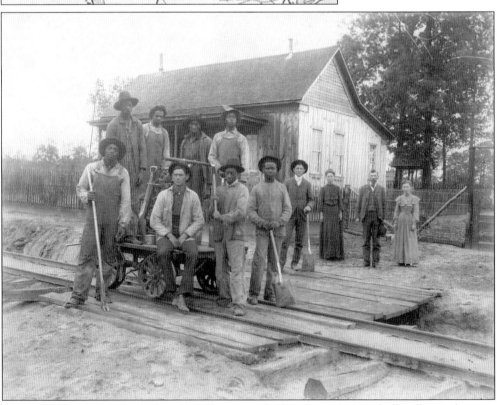

The T&P Railroad was built through Jefferson on the line between Marshall and Texarkana in 1873. This c. 1870s photograph shows a rail construction crew in Jefferson. Note the hand-hewn railroad ties that were used, along with the crude crossing that was built for ground transportation. (Courtesy Jefferson Historical Society and Museum.)

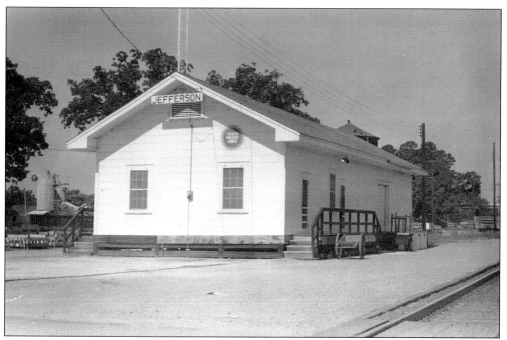

A railroad station was constructed next to the tracks for the convenience of travelers and those businesses shipping freight. Not only does the building bear the name of the city so that it is visible to arriving trains, but the logo of the T&P Railroad is prominently displayed. (Courtesy Jefferson Historical Society and Museum.)

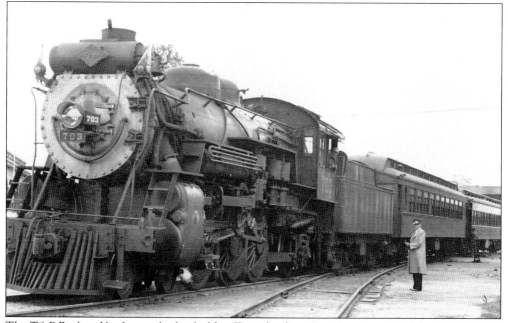

The T&P Railroad had gained a foothold in Texas by the 1870s. Construction difficulties delayed further progress when Jay Gould stepped in to purchase an interest in the railroad in 1879. He was, therefore, indirectly responsible for the railroad coming through Jefferson. (Courtesy Jefferson Historical Society and Museum.)

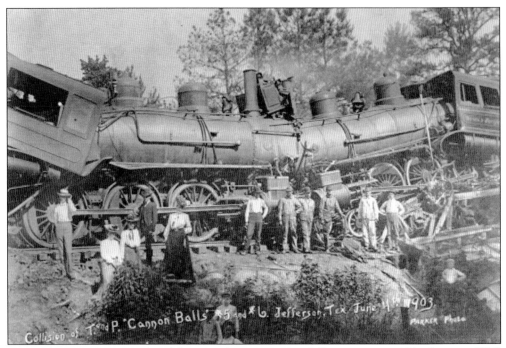

One of the most famous railroad disasters that occurred in Jefferson was in 1903, when two T&P Cannon Ball locomotives collided. The trains met head-on after there was a mix-up in routing orders. The engine crewmen jumped to safety just before the trains hit. (Courtesy Jefferson Historical Society and Museum.)

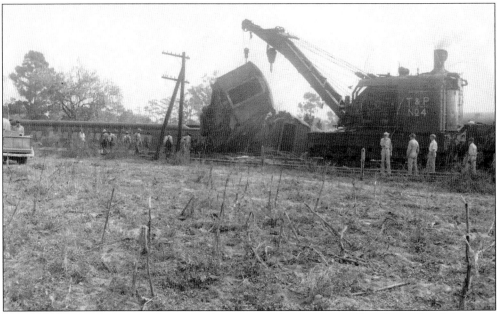

Although there were more collisions and issues over the years, overall, rail travel and shipment continued to flourish. With each year that passed, the rails became safer and more sophisticated. The railroad that Jay Gould had allegedly been dismissed from Jefferson for proposing had become an integral part of the city. (Courtesy Jefferson Historical Society and Museum.)

The T&P Railroad established a presence in Jefferson. This photograph shows a young man standing by a cruiser outfitted for rail travel and bearing the T&P logo on the door. In the background is one of the locomotives on a parallel track. (Courtesy Jefferson Historical Society and Museum.)

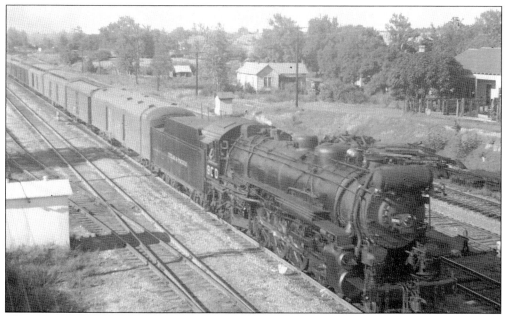

The T&P was soon leased by the Missouri Pacific Railroad, which was also controlled by Gould. The Missouri Pacific gained majority ownership of T&P's stock in 1928 but allowed it to continue operation as a separate entity until they eventually merged on October 15, 1976. (Courtesy Jefferson Historical Society and Museum.)

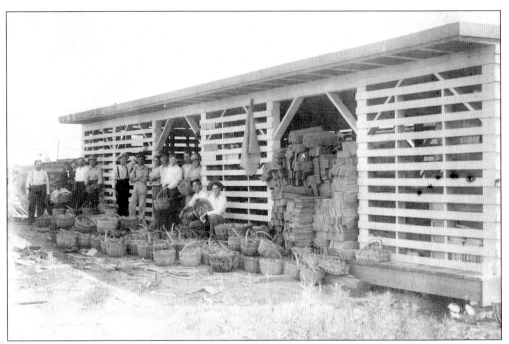

The railroad brought a new dimension to the world of shipping and travel. Businesses, such as this potato storehouse, located their facilities near the railroad to take advantage of the opportunities that the rail offered. (Courtesy Jefferson Historical Society and Museum.)

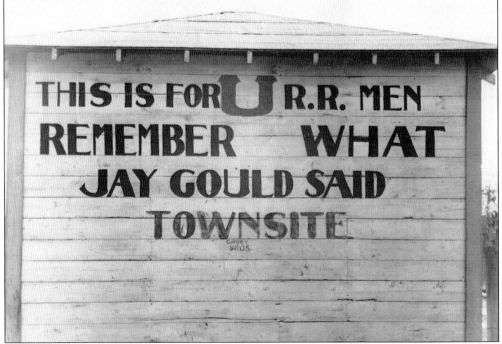

This sign, painted on the side of a real estate office just outside of Jefferson, shows the determination that the city had to be reborn without relying on the railroad. (Courtesy the Old Store and Fudge Shop.)

Today, Jefferson is bounded on the east, west, and northern sides by railroad tracks. The days of the city's rail commerce are long over, however. The trains blow their horns, the crossing arms come down, and the locomotives pass through. Still, they are a reminder of bygone days and a nostalgic part of the city's past.

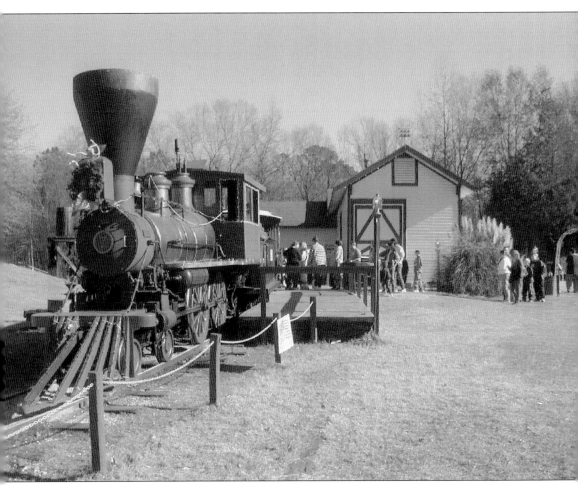

Jefferson's old railroad station has thankfully enjoyed a rebirth. The building was moved a block beyond the commercial tracks and is now the home to a narrow-gauge train that used to take visitors on an hour-long journey along the bayou and through the forests of Jefferson. (Author's collection.)

Eight

RESTORING A COMMUNITY

Jefferson seems to attract people who fall in love with its history and become obsessed with preserving it. The city abounds with homes and buildings that are Recorded Texas Historic Landmarks or are included in the National Register of Historic Places by the Department of the Interior. An entire book could be filled with before and after photographs of these wonderful restorations; this chapter contains only a representative few examples of the loving preservation that has been done in Jefferson. (Courtesy Jessie Allen Wise Garden Club.)

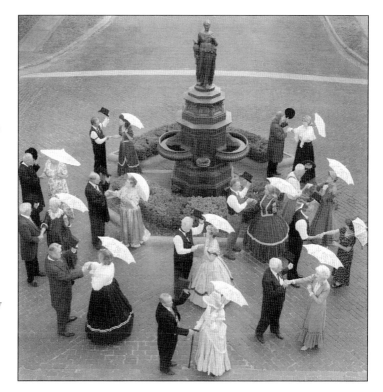

The Torrans-Clopton-Spellings House was built by William P. Torrans in the 1860s. Originally, it was located several blocks away on Lafayette Street. It was later purchased by Dr. Albert G. Clopton and his wife, Anna. Dr. Clopton had his office at the house. (Courtesy Jefferson Historical Society and Museum.)

After 1882, the residence was moved to its current location by Soloman A. Spellings (1841–1903), a Confederate veteran who operated a livery business on Polk and Henderson Streets. Additions were made in 1932 and 1947 under the ownership of grocer Hosea D. Watson (1879–1957). (Author's collection.)

Originally a hotel built in 1865, the Haywood House was reportedly one of the finest hotels west of the Mississippi. Board and lodging was advertised as $10 per month, payable weekly. It was built, owned, and operated by H.P. Maybry, who lived there with his family. (Courtesy Jefferson Historical Society and Museum.)

The Haywood House eventually fell into ruin for almost 20 years but was finally purchased and restored as the Texas History Museum, which hosted a collection of rare Texana and banking memorabilia. It has since been converted into a private residence with its historical presence preserved. (Author's collection.)

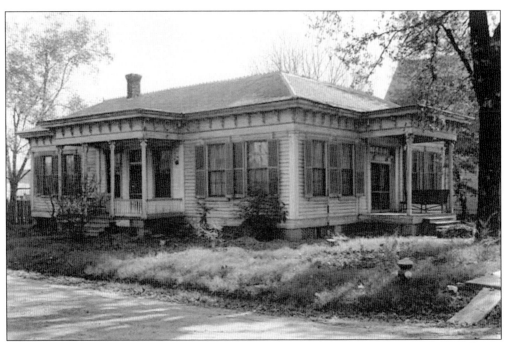

Construction on this Greek Revival home began in 1860 by Noble A. Birge, a prominent Jefferson businessman. It featured exterior trim and porch columns that were inspired by the interior grand salons of the elaborate steamboats that visited Jefferson. (Courtesy Jefferson Historical Society and Museum.)

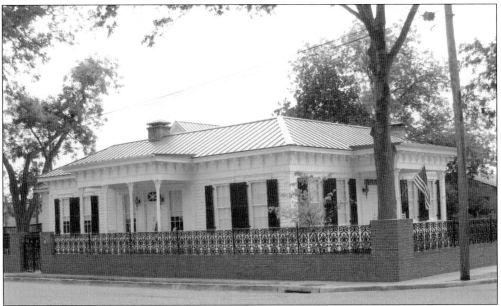

In 1878, the house was purchased by the family of Anna Beard, and they occupied the house until 1895. Another owner, Estella May Fonville Peters, enclosed the covered porch, including the original water well. Many years and several owners later, the house has been restored to its original beauty and was one of the first homes on the Pilgrimage Tour and on the Christmas Candlelight Tour of Homes. (Author's collection.)

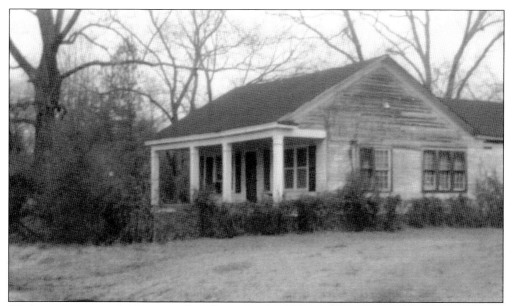

The house known as the Grove was built by W. Frank Stilley, a Jefferson cotton factor and merchant, in 1861. It is a Greek Revival structure externally with Creole influences on the interior. Charlie Young, a freed slave, bought the home in 1885, and a member of his family lived there for almost 100 years. (Courtesy the Grove.)

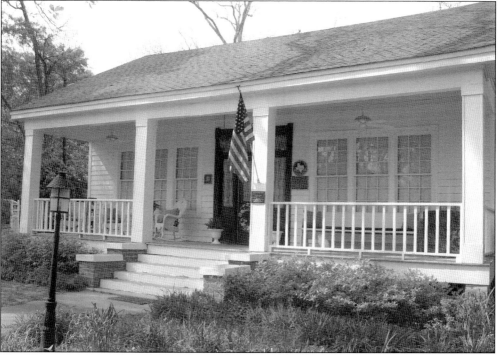

The Grove has not only been restored to its original beauty but is also listed in the National Register of Historic Places and is a Recorded Texas Historic Landmark. It features antique furniture dating back to different owners throughout the years as well as hardwood floors and nine-and-a-half-foot ceilings. (Courtesy the Grove.)

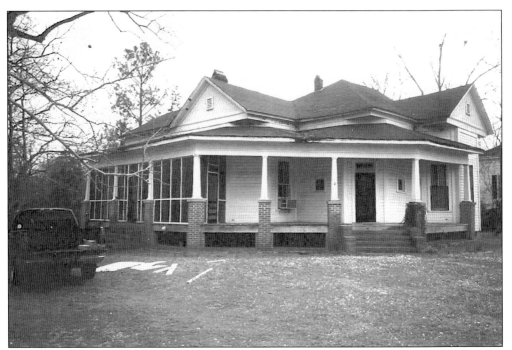

The Hale-Walla House, built in 1880, was home to several families, but James Hale Jr. and his wife lived in the house for the longest period. They purchased the house in 1917 and remained there for 78 years. James Hale operated his father's livery business for many years before opening a local Ford Motor Car Agency. (Courtesy Marshall and Diana Walla.)

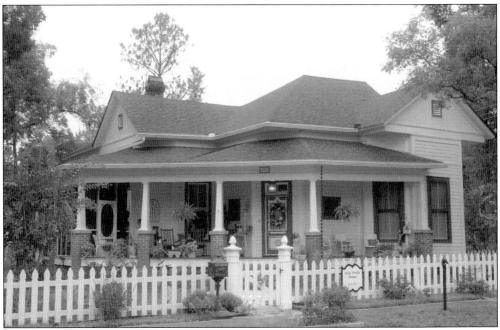

The house, now restored to its original beauty, is a rare example of the Queen Anne cottage style. The large porch wraps two sides of the home, and the interior features 12.5-foot ceilings and heart of pine floors. (Courtesy Marshall and Diana Walla.)

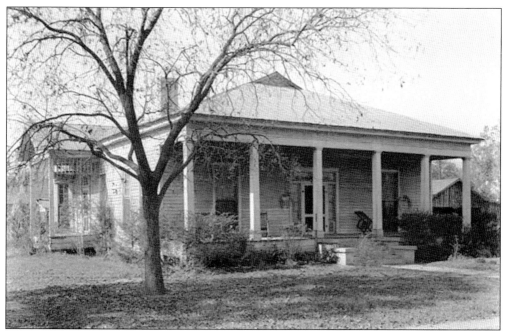

This house was built around 1867 by Col. David Browning Culberson Jr. Originally from Georgia, he moved his family to Jefferson to practice law. Culberson played a part in some of the most famous trials in Jefferson—he was a defense attorney in the Stockade Case of 1869 and defended Abe Rothschild in the Diamond Bessie murder trial. (Courtesy Jefferson Carnegie Library.)

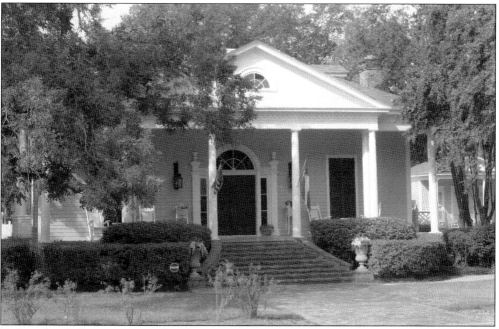

Today, the Culberson House has been reborn with its beautifully symmetrical shape, low rooflines, columns, and pediments, all inspired by Greek temples. The house retains original interior doors, hand-hewn ceiling beams, and brick walls. It even has a secret passageway. (Author's collection.)

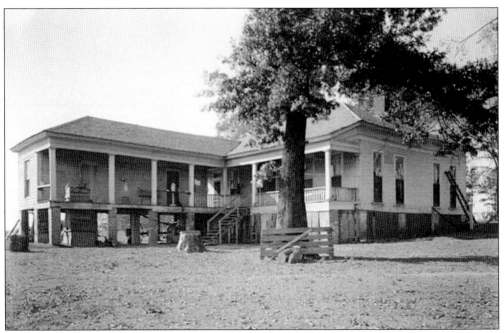

Blue Bonnet Farm is a Louisiana-style raised cottage located on historic Trammel's Trace at the southern side of Jefferson. The original home of cypress and pine cut on the property was completed in 1869 with an appended ell dating from 1847. It featured heart of pine flooring and 13.5-foot ceilings. (Courtesy Jefferson Carnegie Library.)

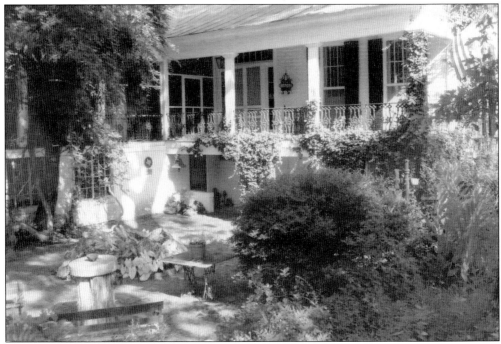

A lower level formed of brick was added when the present owner's family purchased it in 1938. Bluebonnet Farm was one of the first homes featured on Jefferson's Historic Pilgrimage and has been on the tour 10 times during the 60 years of the event. (Courtesy James and Frances Rounds.)

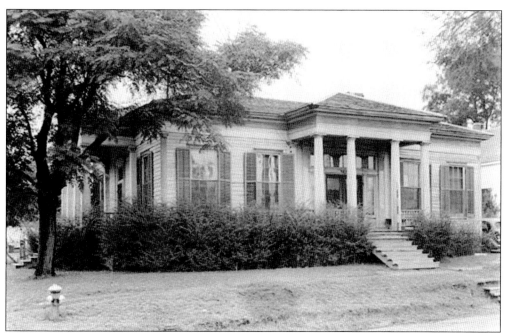

This one-story raised home is one of the most notable examples of the Greek Revival style in East Texas. Construction on the house started in 1839 and began with only two rooms. Three additional rooms were added in 1850, forming a U-shaped structure, with a sixth room being added in 1939 to give the home its rectangular shape. (Courtesy Jessie Allen Wise Garden Club.)

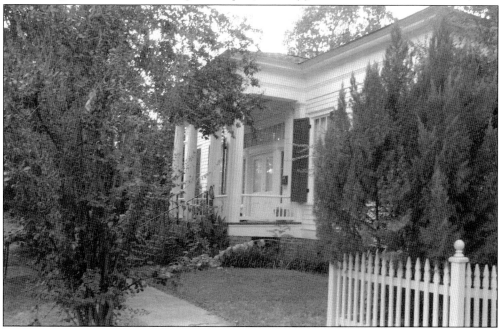

The first owner of the home known as the manse was Gen. James Harrison Rogers, but in 1903, the Cumberland Presbyterian Church purchased it to use as the pastor's home. The manse was included in the 1936 Historic American Buildings Survey as recorded at the Library of Congress. (Courtesy Jefferson Historical Society and Museum.)

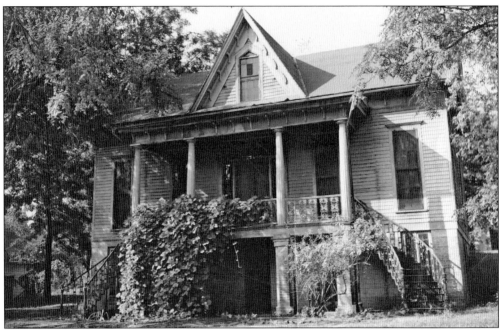

The Sedberry-DeSpain House has been owned by the editor of a Confederate newspaper, a cotton merchant, an attorney, a schoolteacher, a pharmacist, a bank cashier, and a steamship owner. It was originally built in 1853. (Courtesy Jefferson Historical Society and Museum.)

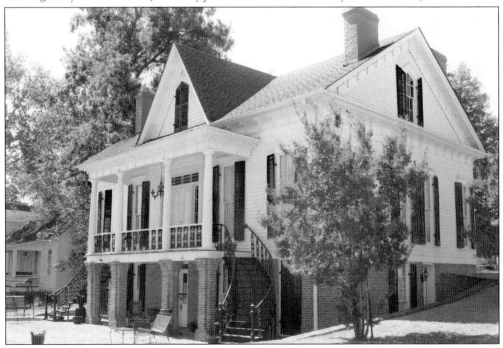

This house was built in a Victorian style with elements of Greek Revival and Louisiana "raised cottage" architecture. Because of the unique architecture and history, the house has been designated as a Texas Historical Landmark and is in the National Register of Historic Places. (Author's collection.)

Nine

JEFFERSON'S HISTORIC CHURCHES AND OAKWOOD CEMETERY

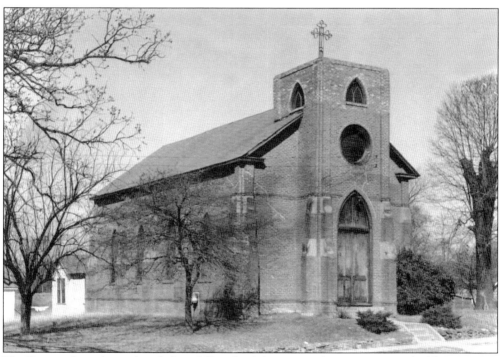

The Episcopal parish was founded in 1860 with 16 charter members meeting in a building on Main Street. Bishop Alex Gregg led the congregation during those founding years. Rev. E.G. Benners became the first actual resident clergyman in 1869, serving for 25 years until 1894. (Courtesy Jefferson Historical Society and Museum.)

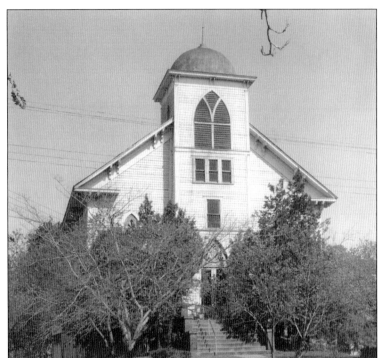

The First United Methodist Church of Jefferson was one of the initial congregations organized in Jefferson. Established in 1844, the East Texas Methodist Conference named Rev. James Baldridge as its pastor. According to the records, one year later, the church had "fifty white members and three slaves." (Courtesy Jefferson Historical Society and Museum.)

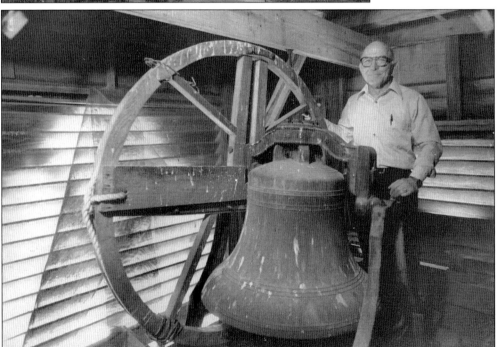

The congregation wanted a bell for the tower of the new church, so they began a drive to collect Mexican silver dollars to cast it. When 1,500 were collected, they were delivered to the Menneley Bell Foundry of Troy New York in 1858. The completed bell was shipped to Jefferson on a steamship and installed. Shown with the bell is Milton Bass, who has been ringing the bell since he was a teenager. (Courtesy First United Methodist Church of Jefferson.)

In 1866, Father Giraud purchased the property at the corner of Polk and Lafayette Streets. By September 1867, the parish completed their church building, constructed with money sent from Lyon, France, and named it Immaculate Conception. From a letter to "Mon chere cousin" dated September 2, 1867, Father Giraud wrote, "Joy fills my heart, our church is finished and we are having Mass—my flock is small—about 50." The church experienced a period of growth and prosperity until tragedy struck on Sunday evening, January 5, 1992, when a fire swept through the sanctuary and destroyed the church. While construction to rebuild was under way, the parish met in the city's playhouse, which was once a Jewish synagogue, and later they convened in the Methodist church. The Immaculate Conception parish mustered their energy and resources and raised the new building to the beauty and grandeur of the original. (Both, courtesy Jefferson Historical Society and Museum.)

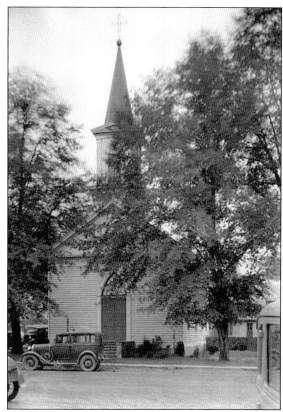

Organized in 1855 by a local farmer named William Freeman, seven out of the 11 Immaculate Conception founding members were from his family. The deed to the property where the church now stands was recorded on October 11, 1860. A brick church was constructed there in 1869; tragically, the church building burned in 1944. The congregation built the new church where it still stands today. (Courtesy First Baptist Church, Jefferson.)

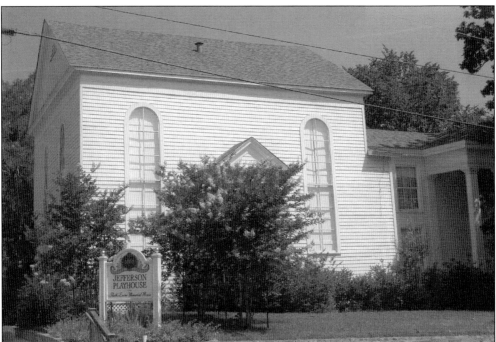

Now a playhouse, this building was originally constructed as a Jewish synagogue with the rabbi's house attached. It was then purchased by the local Catholic Church and became a combined convent, hospital, and private school in this building and the adjoining two-story house. (Courtesy Jessie Allen Wise Garden Club.)

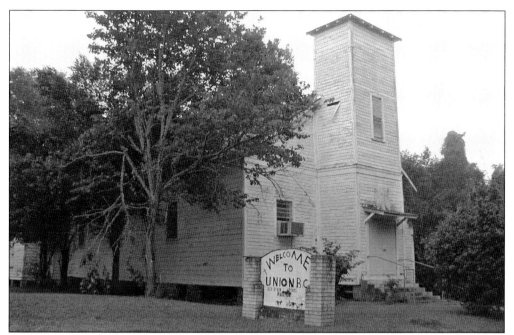

The Union Missionary Baptist Church was first established in 1842, and its doors were open to all people of color. No description of the church building or the denomination exists of that earliest sanctuary. When Union troops occupied Jefferson following the Civil War, numerous buildings were burned, including Union Missionary Baptist Church. All federal troops were removed from Jefferson by 1871; however, in the next few years, a new structure, the Union Missionary Baptist Church, was built on the property and still stands today. (Author's collection.)

According to a 1917 writing, the Union Missionary Baptist Church "has a membership of 180, and pays its pastor $200 per annum. The church has a splendid Sunday School, Star Light Band and W.H.M. Society. The church stands for the interest of the denomination in all the phases of its work." (Author's collection.)

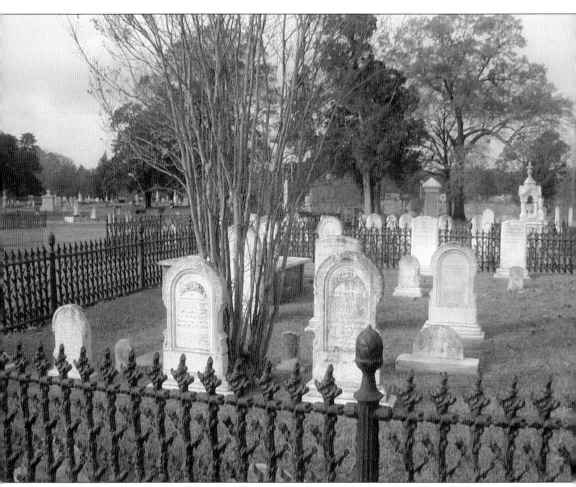

No trip to Jefferson is complete without a visit to Oakwood Cemetery. The earliest documentation of Jefferson indicates that burials were made in a public graveyard between Camp, Houston, and Cypress Streets along the Big Cypress Bayou. *The Cemetery Records of Marion County, Texas* by Mrs. Jesse M. DeWare III and Mrs. Amos K. Payne states, "In 1846, Allen Urquhart, the donor of a public burial tract for Jefferson, substituted a 'larger and more beautiful site' to which prior burials were then moved." It is unknown how many graves at the old site were moved to present-day Oakwood. Burials apparently commenced at the new location; the oldest headstone in the cemetery standing today is that of Rev. Benjamin Foscue, who died of cholera on January 1, 1850. (Author's collection.)

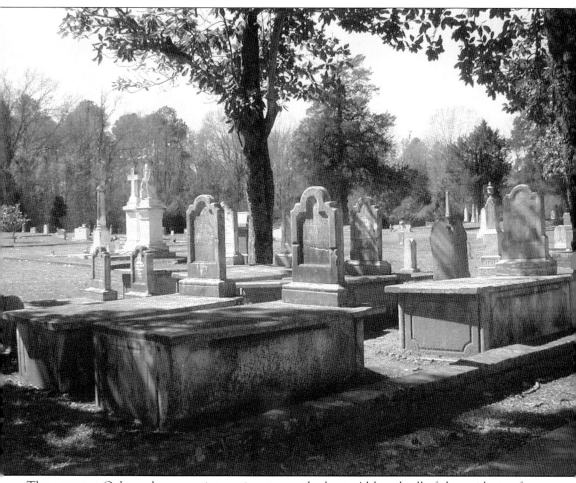

The graves at Oakwood are very interesting, to say the least. Although all of the residents of the cemetery are belowground, in many cases faux crypts exist to mirror the traditions of New Orleans and lower Louisiana, where bodies were buried aboveground because of the high water table. (Author's collection.)

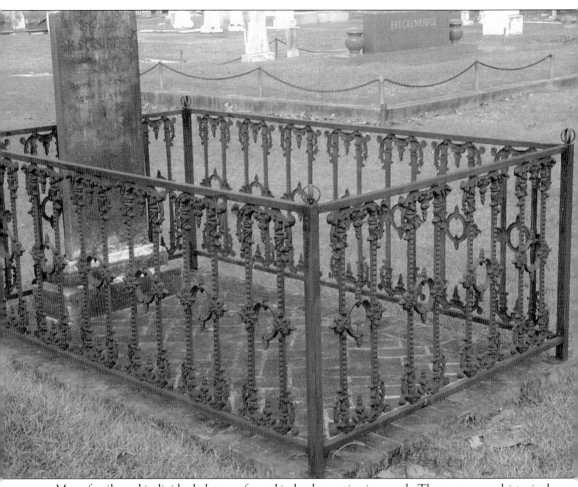

Many family and individual plots are fenced in by decorative ironwork. There are many historical patterns, and all are beautiful in their own right. A visitor will find that all of the cemetery ironwork is painted black, a tradition of the day. (Author's collection.)

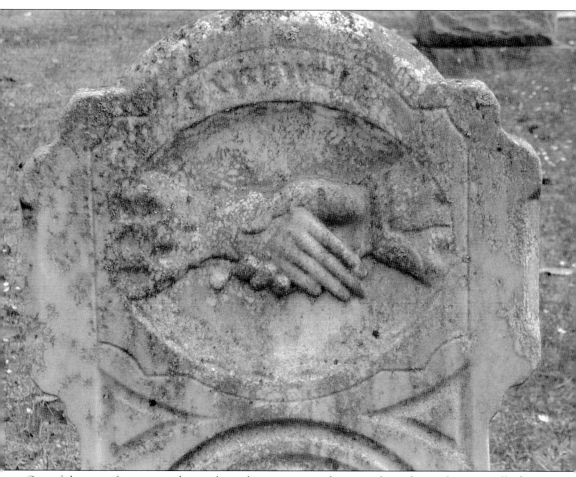

One of the most fascinating things about the cemetery is the artwork on the tombstones. All of the carvings and inscriptions have meaning; for example, these two hands clasping indicate a husband and wife being rejoined in the afterlife. (Author's collection.)

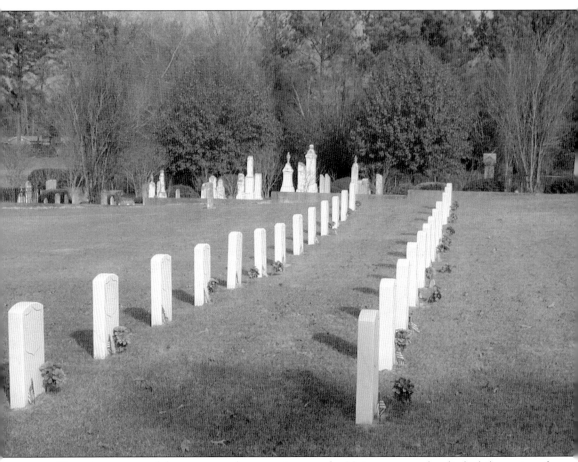

There is one part of the cemetery that was given to the Union troops who died while stationed in Jefferson during the Reconstruction. In all, 26 soldiers died. Some deaths were due to disease, while others occurred in the course of being a Federal soldier stationed in the South. (Author's collection.)

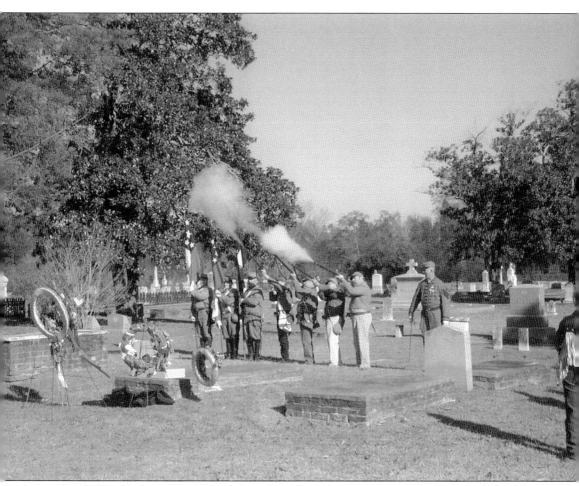

Many Civil War soldiers are buried in Oakwood, and reenactor units periodically pay tribute to these fallen heroes. Here, a group is saluting Col. Richard Phillip Crump, who, after almost a century, was finally getting his military marker. (Author's collection.)

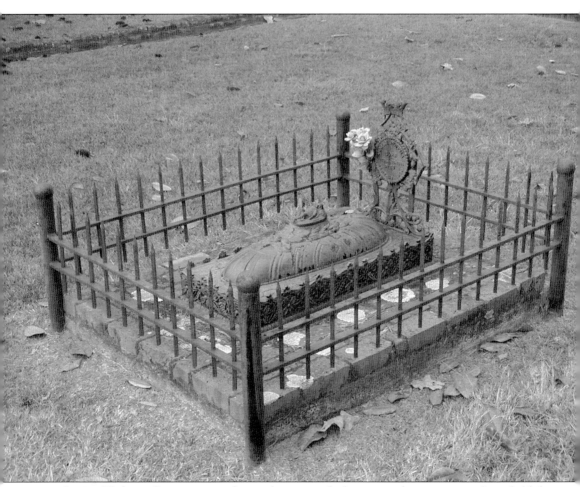

Some of Oakwood's stories are sad, as is the case with this ironwork grave topper for a child that was only two years old. It features a small child lying on the very top. The marker always seems to have flowers placed on it, even though the child died over 100 ago. (Author's collection.)

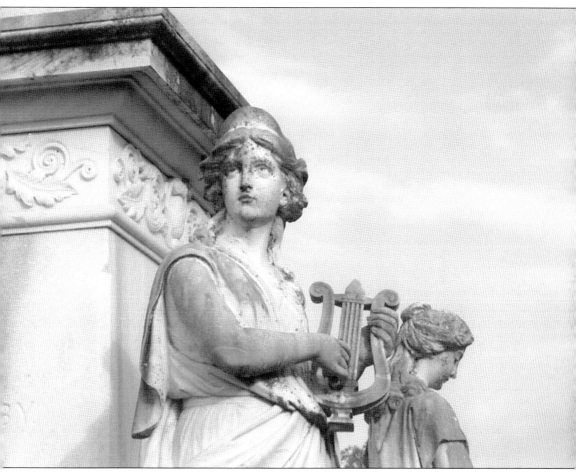

The statuary at Oakwood is one of the most fascinating aspects of the cemetery. It is truly a photographer's paradise. Different statues represent different things, and the study of each of them is extremely interesting. (Author's collection.)

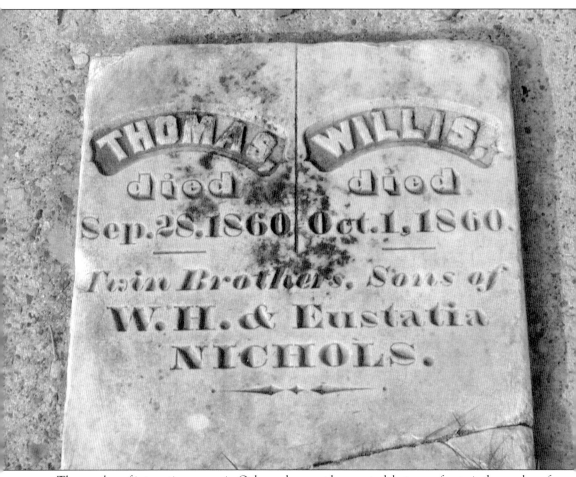

The number of interesting graves in Oakwood cannot be counted, but one of note is the marker of Thomas and Willis Nichols, twin brothers who died only a few days apart. One can only wonder about their story and what caused their deaths. (Author's collection.)

Ten

THE REBIRTH OF
THE CITY ON THE BAYOU

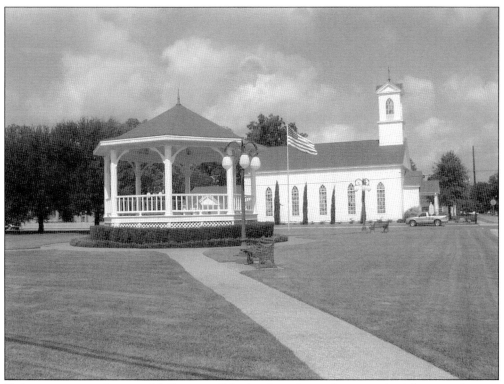

Today, a visitor to the city of Jefferson will find a place that embraces and celebrates its history. Named "the Bed and Breakfast Capital of Texas" by the Texas Legislature, the city features dozens of unique inns. It is a peaceful place of parks, horse-drawn carriages, fountains, and festivals, which are held throughout the year. Visitors from all over the world flock to the city on the bayou for relaxation and celebration. (Author's collection.)

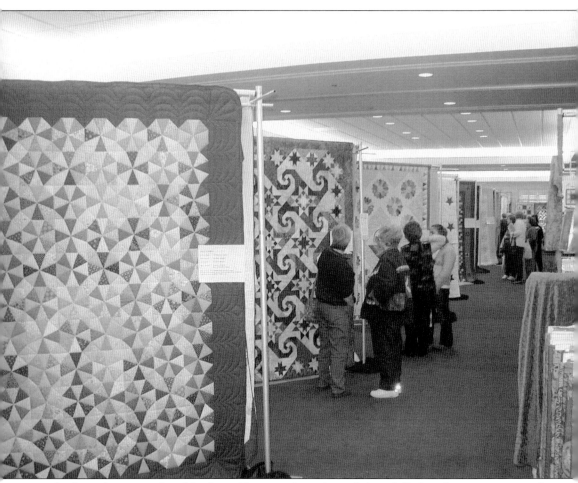

In the early pioneer days, Northeast Texas residents depended on skilled craftspersons to provide the necessary items to maintain a comfortable home and lifestyle. Unfortunately, over time, handcrafted items have been replaced with mass-produced, imported goods, many times at the sacrifice of quality and beauty. The annual Jefferson Quilt Show showcases craftsmanship from a bygone time. (Author's collection.)

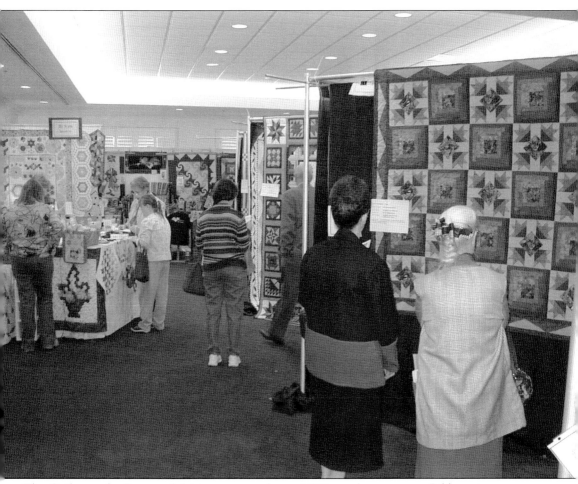

The Quilts on the Bayou exhibition attracts almost 1,500 people every year. Ribbons in many categories are awarded to some of the finest handcrafted quilts that can be seen anywhere. Over 100 quilts are displayed, along with workshops and lectures, and attendees have time to enjoy the many amenities of the city. (Author's collection.)

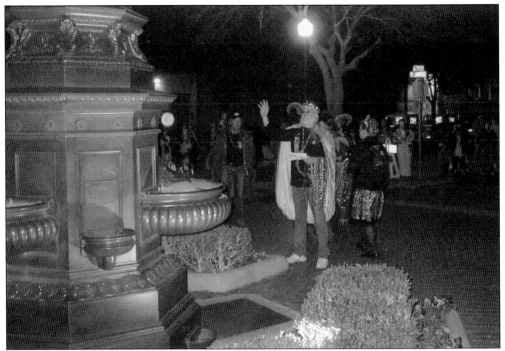

Mardi Gras is a huge celebration in Jefferson, with its ties going back over 100 years when travelers from New Orleans brought the festival to town. Each year, the Doo-Dah Parade opens the weekend on Friday evening. The Mardi Gras king leads the procession and pauses at Sterne Fountain before the goddess Hebe to call for blessings over the festivities, pronouncing the beginning of Mardi Gras. (Author's collection.)

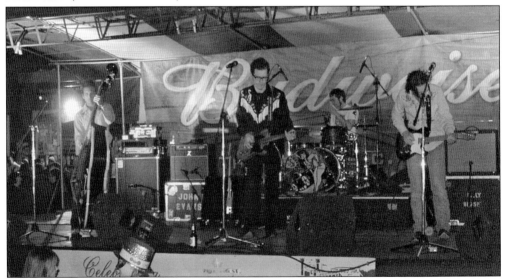

The streets of town are filled with food, frivolity, and music. Unlike wilder celebrations around the country, Jefferson's Mardi Gras is decidedly family-friendly. It is a celebration that mothers, dads, kids, and grandparents all enjoy. The festival offers a beer garden with live music for the grown-ups and carnival rides and cotton candy for the kids. There is literally something for everyone in this safe, controlled environment. (Author's collection.)

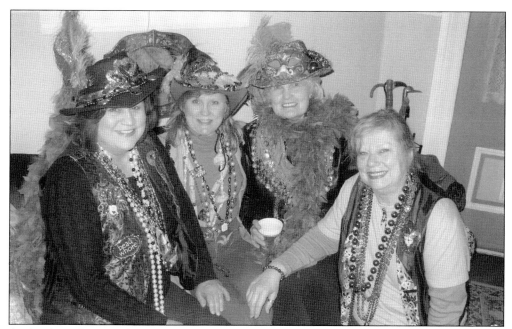

As they have for years, locals deck out in festive attire and take to the streets. Diets are temporarily traded for corn dogs and funnel cakes while exercise programs are exchanged for catching beads during the parades. Mardi Gras trees adorn historic homes, and gold, purple, and green decorations adorn the porches. (Author's collection.)

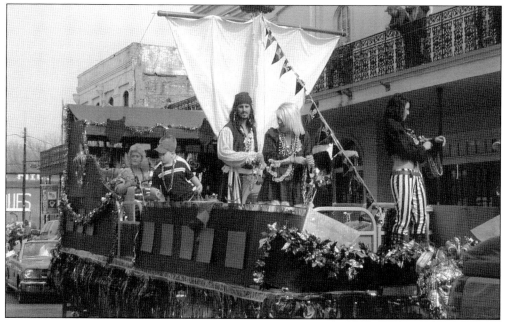

There are two important elements to any Mardi Gras parade: floats and beads. Jefferson's parades enjoy both, and everything is coordinated by the Krewe of Hebe. The krewe spends the entire year meeting and planning the upcoming celebration, handling all aspects from laying out parade routes to working with the many vendors set up on the streets and sidewalks of town. (Author's collection.)

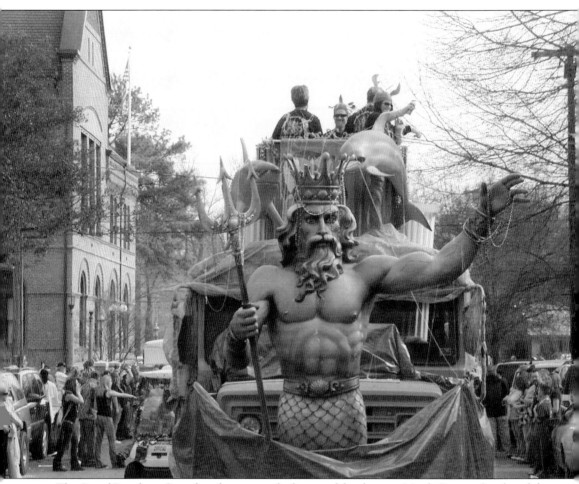

The Grand Parade on Saturday afternoon is the largest of the three on Mardi Gras weekend, and the streets are lined with visitors and locals, all hoping to catch a string of beads or a commemorative doubloon. The population of Jefferson may only be 2,000 people, but on Mardi Gras weekend, as many as 15,000 people come to town for the festival. (Author's collection.)

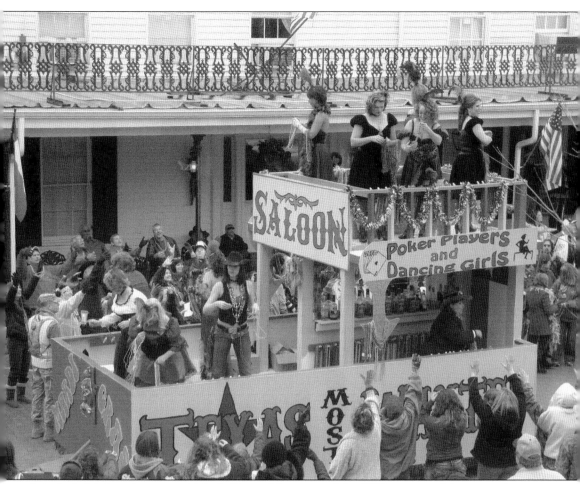

It is doubtful that the original Mardi Gras celebrations of the 1800s were as elaborate as their present-day versions, but as with everything else that Jefferson does, it has retained the charm and small-town feel of the festival—even with as large as it has grown. That will hopefully be a pattern for years to come. (Author's collection.)

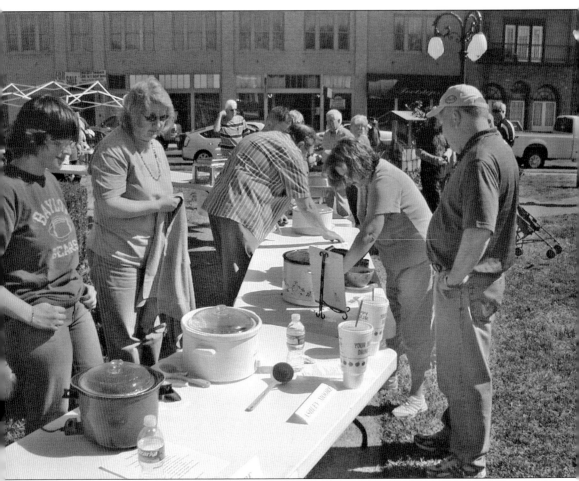

On the Saturday morning of St. Patrick's Day weekend, one will notice early activity at Otstott Park in downtown Jefferson. The gazebo is draped in green and ringed with tables, and home-kitchen chefs from all over town bring their individual versions of Irish stew for the annual cook-off. Here, one can find delicious, but widely varied, interpretations of this classic Irish dish. Visitors receive a bowl and a spoon and, after the judging, are free to sample all the entries and pick their favorite. (Author's collection.)

Of course, what is any celebration without music? During the St. Patrick's Day celebration, the park rings out with traditional Irish music, complete with the occasional bagpipe screeching its distinctive sounds across the crowd. (Author's collection.)

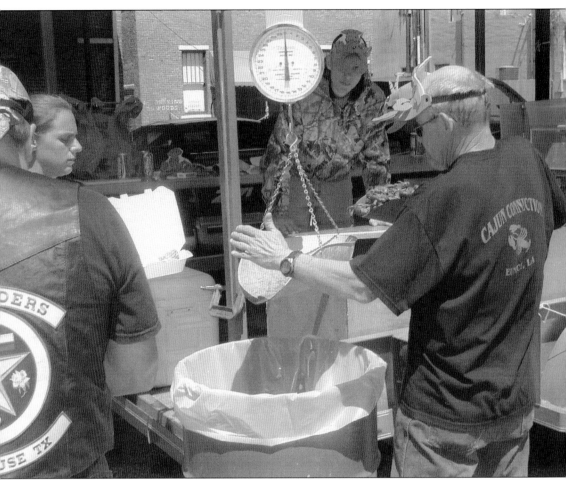

Locals and visitors alike look forward to Jefferson's Crawfish Festival. Whether one purchases these delicious mudbugs by the plate or by the pound, they are freshly boiled right in front of the buyer and ready for eating. Concessions sell accompanying items and beverages, and rows of picnic tables are nearby. (Author's collection.)

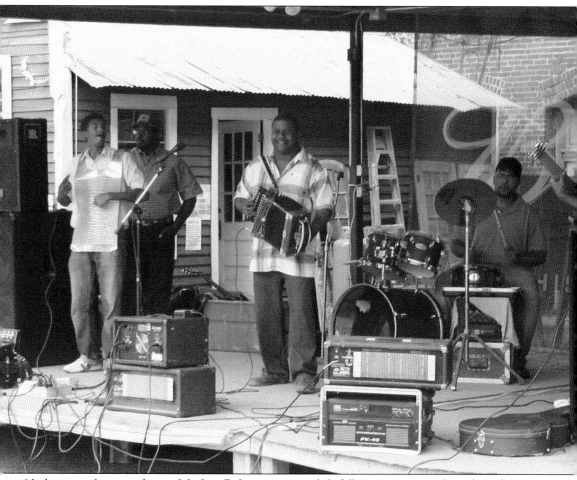

Nothing goes better with crawfish than Zydeco music, so while folks are enjoying a plate of crawfish, they are treated to live bands with that dynamic beat. The Crawfish Festival is an all-day culinary and musical event that people look forward to all year long. (Author's collection.)

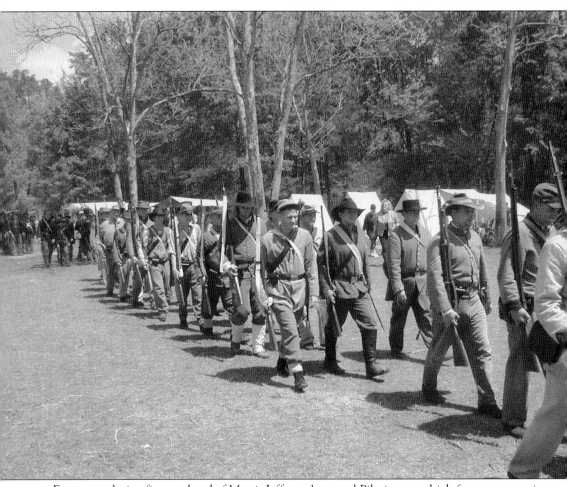

Every year during first weekend of May is Jefferson's annual Pilgrimage, which features an entire weekend of events. Civil War reenactors camp all over town, and of course, skirmishes ensue. Visitors are able to walk through the campsites, and a special living history presentation is given to schools that bring entire classes to town. (Author's collection.)

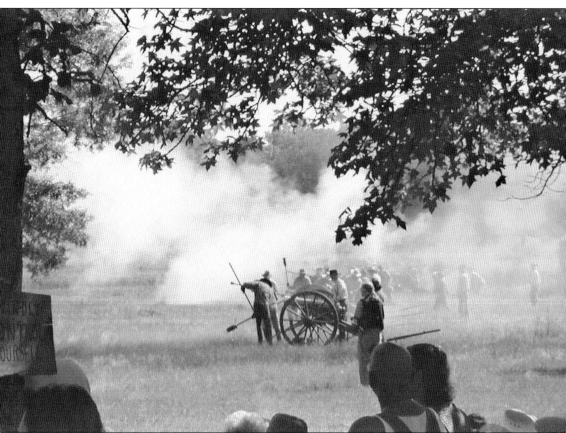

Jefferson was never actually the scene of a Civil War battle, but Union troops had set out to burn the city. Thankfully, they were stopped in Mansfield, Louisiana, but had they not, the Battle of Port Jefferson would have been a part of Civil War history. The reenactment held at Pilgrimage portrays the legendary Battle that Never Was. No one knows how the battle would have turned out, so both outcomes are presented on different days. (Author's collection.)

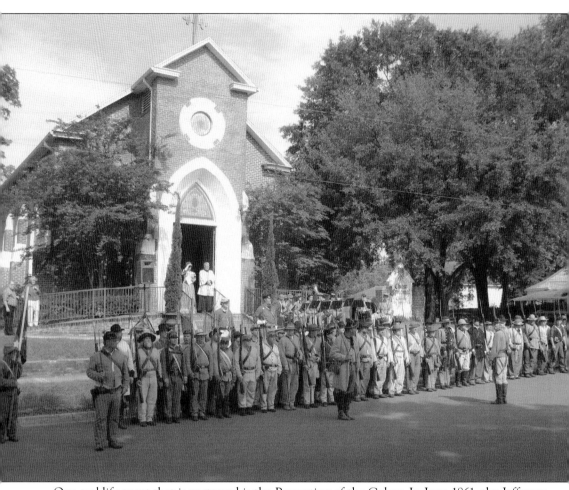

One real-life event that is portrayed is the Presenting of the Colors. In June 1861, the Jefferson Guards were mustered in Jefferson and preparing to march out of town to join the war. A ceremony was held in front of Christ Episcopal Church, where a flag was given to the company and a young lady named Fannie Benners gave a rousing speech to send the men off to battle. (Author's collection.)

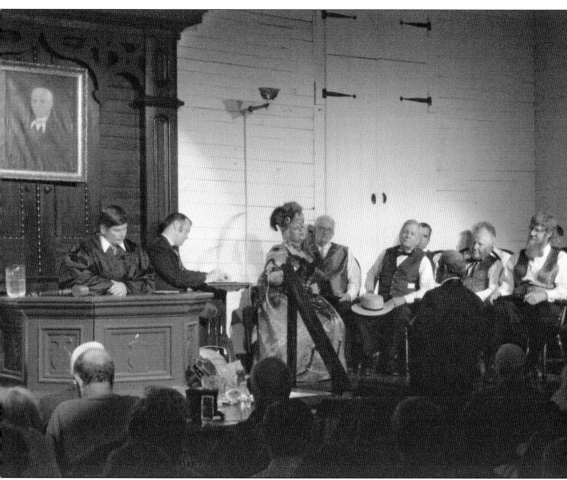

Diamond Bessie Moore was a young woman found murdered outside of Jefferson on February 5, 1877. With no family to claim her, the townspeople took up a collection to bury her in Oakwood Cemetery. Her suspected killer was eventually found, and the town sought justice in what became the trial of the century. The *Diamond Bessie Murder Trial* play is presented every year during Pilgrimage. (Courtesy the Jessie Allen Wise Garden Club.)

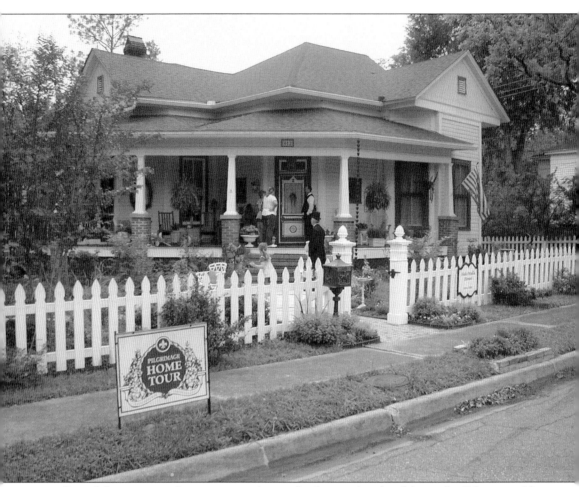

One of the most popular attractions during the first weekend in May is the Pilgrimage Home Tour. Every year, four of the historic Jefferson homes open their doors to the public. A single ticket purchased from the Jesse Allen Wise Garden Club admits a visitor to all of the homes. (Courtesy the Hale-Walla House.)

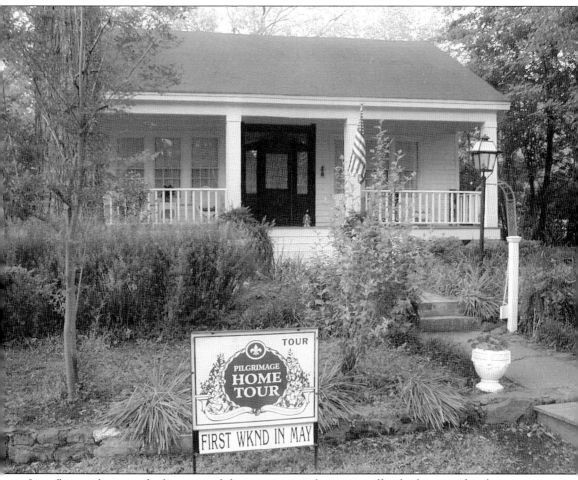

Live flowers decorate the homes, and docents in period costume offer the history of each room in the house. Visitors are treated to period antiques and many stories of the people and places associated with Jefferson's past. Since four different homes are shown every year, every Pilgrimage is a unique experience. (Courtesy the Grove.)

The Historic Jefferson Ghost Walks takes visitors on a tour of the spirited side of town. As can be expected in a city with structures dating back to the 1800s, a few chilling ghost stories have surfaced over the years. (Courtesy the Historic Jefferson Ghost Walk.)

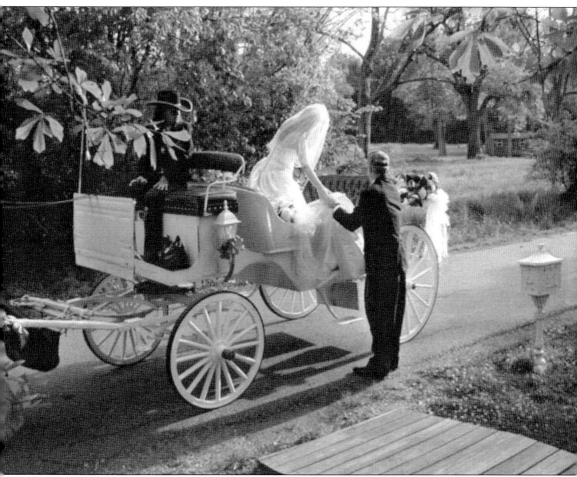

Horse-drawn carriages can be seen slowly and peacefully plodding along the streets of Jefferson on any given day. Whether they are giving visitors a historical tour or delivering a bride to the altar, the carriages feature knowledgeable drivers and pampered horses. No visit to town is complete without a carriage tour. (Author's collection.)

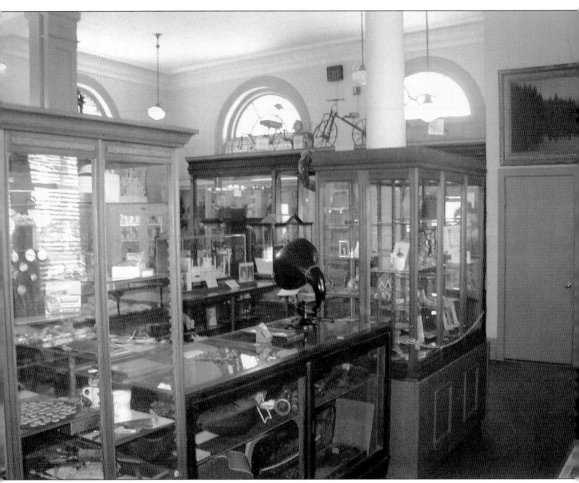

The city features five different museums; the oldest and largest of which is the Historic Society and Museum. It features items and artifacts from Jefferson's past, a room of Caddo Indian relics, a collection of weaponry, and an incredible art galley, all housed in the original federal courthouse building on Austin Street. (Courtesy Jefferson Historical Society and Museum.)

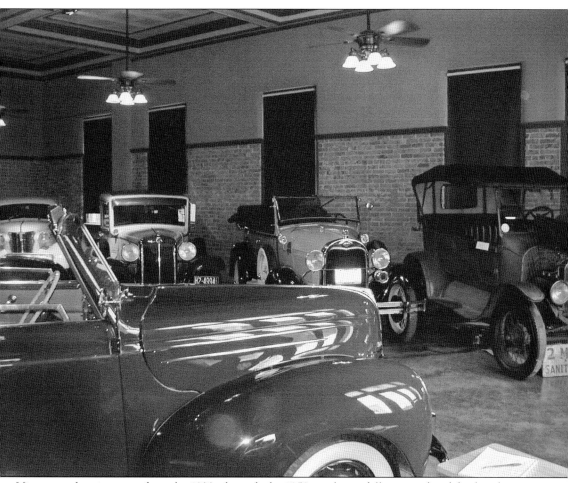

Vintage and antique cars from the 1920s through the 1950s are beautifully restored and displayed at the Lafayette Street Vintage Car Museum. These beautifully restored cars range from convertibles to ragtops and hardtops. They are shown with a backdrop of automobile memorabilia in what was once a doctor's office on Lafayette Street in Jefferson. (Courtesy Lafayette Street Vintage Car Museum.)

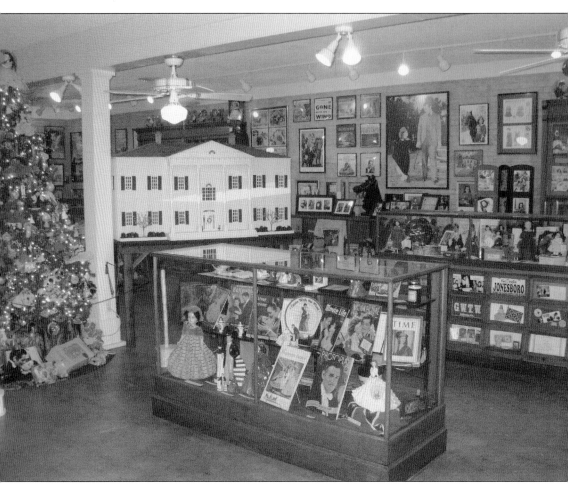

Scarlett O'Hardy's Gone With the Wind Museum features one of the largest collections in the South showcasing memorabilia from the epic movie and book of the Old South. There are many rare items, such as vintage movie posters, a first edition novel signed by Margaret Mitchell, a personal letter by the author, and promotional novelties and items inspired by the original movie release. (Courtesy Scarlett O'Hardy's Gone With the Wind Museum.)

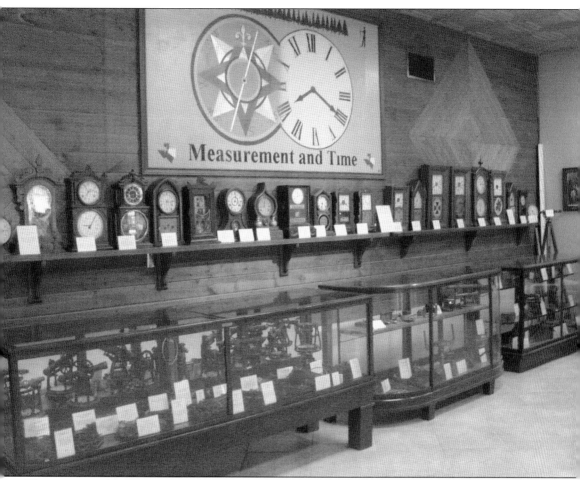

The Museum of Measurement and Time on Polk Street contains measuring devices of all types and sizes. Inside the museum are clocks, surveying instruments, maps, land documents, calculating devices, and, just for good measure, a collection of salt and pepper shakers that will amaze and intrigue any visitor. (Courtesy the Museum of Measurement and Time.)

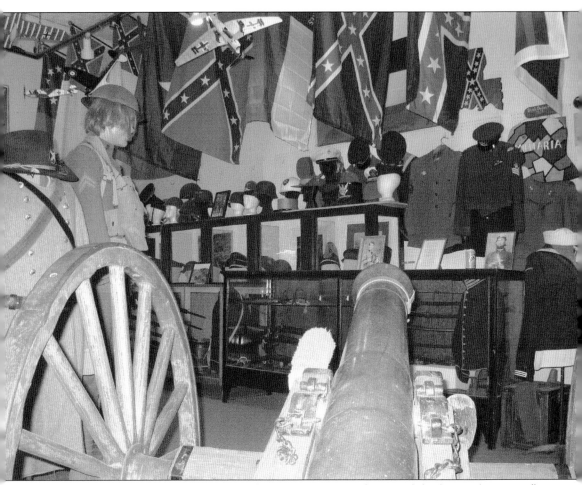

The Mason-Dixon Line Military Exhibition is a museum of memorabilia from military conflicts in which the United States has participated. A visitor will see a display of flags, vintage pistols, rifles and knives, military uniforms, photographs, and even a cannon for good measure. The staff is extremely knowledgeable, and it is the perfect place for a conversation on anything military. (Courtesy Mason-Dixon Line.)

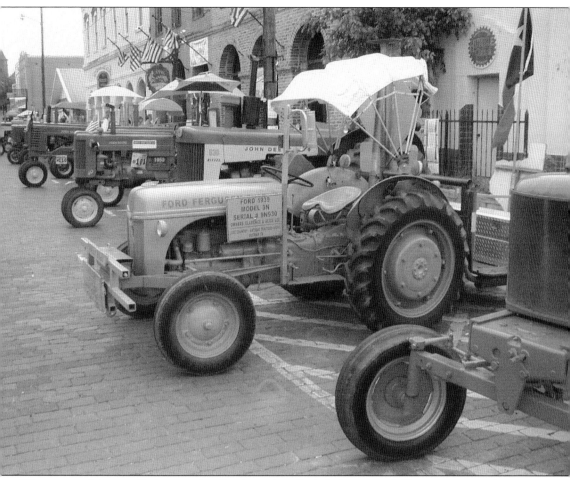

The types of shows, displays, and collections that find their way to Jefferson are sometimes surprising. For example, the Vintage Tractor Show includes some of the finest farm machinery found anywhere, from a 1936 McCorick-Deering Farmall to a 1946 Model A John Deer and anything imaginable in between. (Author's collection.)

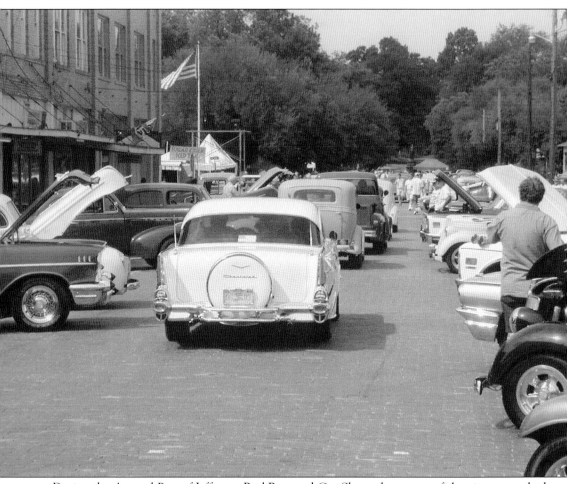

During the Annual Port of Jefferson Rod Run and Car Show, the streets of the city are packed with vintage automobiles. The cars have been restored, polished, and tricked out to perfection. Not only can a visitor spend several hours perusing the cars, but there are also prizes, food, music, and everything one needs for a weekend full of fun. (Courtesy Port of Jefferson Rod Run and Car Show.)

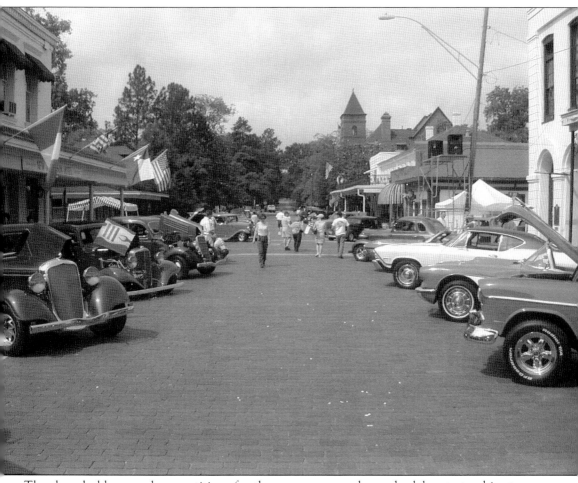

The show holds several competitions for the car owners and awards elaborate trophies to commemorate victory. More importantly, all the money that it raises over the weekend goes to charity, making this not only an entertaining weekend, but one that is worthwhile as well. (Courtesy Port of Jefferson Rod Run and Car Show.)

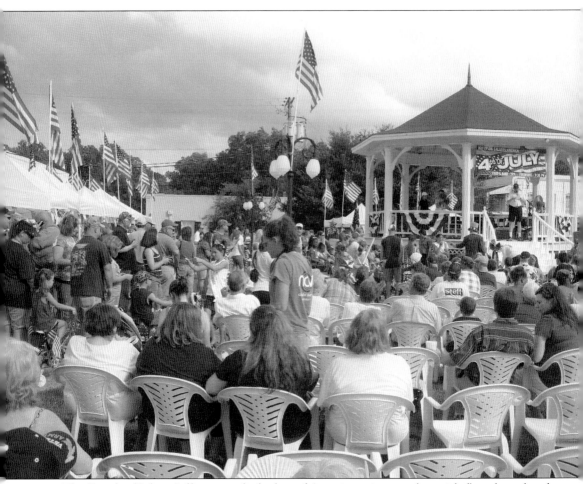

The Fourth of July in Jefferson is a little slice of American pie, complete with flags, brass bands, and choirs singing patriotic songs in the gazebo. The Boy Scout troop grills hot dogs for a fundraiser while the high school cheerleaders face paint for the kids in the crowd. A visitor will find everything from a homemade ice cream contest to a kid's parade with tricycles and wagons sporting American flags and banners. (Courtesy Jefferson Salutes America.)

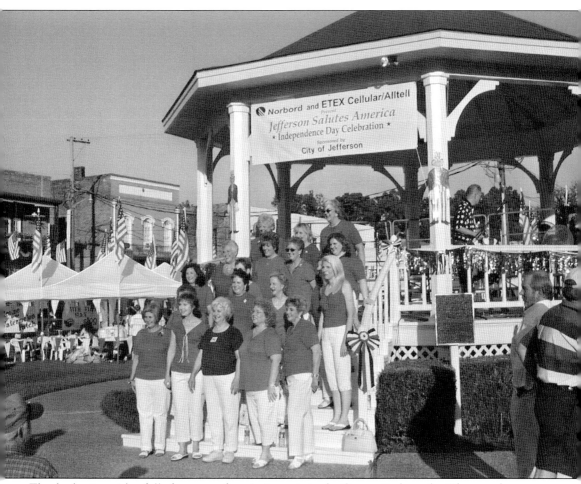

The day begins with a full afternoon of patriotic music in the Otstott Park gazebo. There are lawn chairs set up for the crowd to enjoy and sing along with the tunes, and the children's tricycle/bicycle parade weaves in and out for everyone to applaud. A rubber duck race in the bayou is not only is a popular fundraiser, but it also awards the winner with a cash prize. (Courtesy Jefferson Salutes America.)

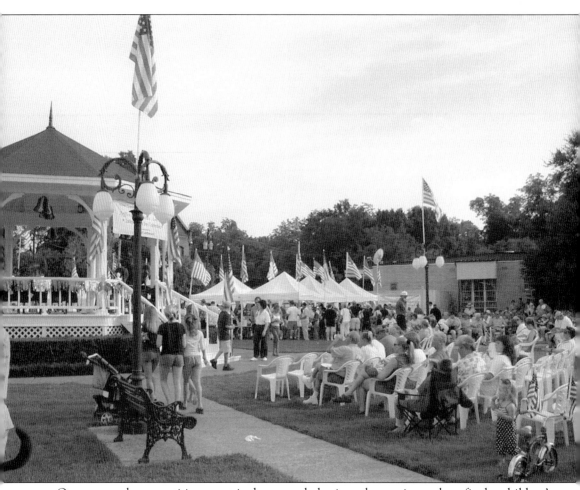

One extremely competitive event is the annual charity cake auction to benefit the children's reading program at the Jefferson Carnegie Library. The bidding can become fierce, as prices for a single cake have soared into the hundreds of dollars—all to benefit children. (Courtesy Jefferson Salutes America.)

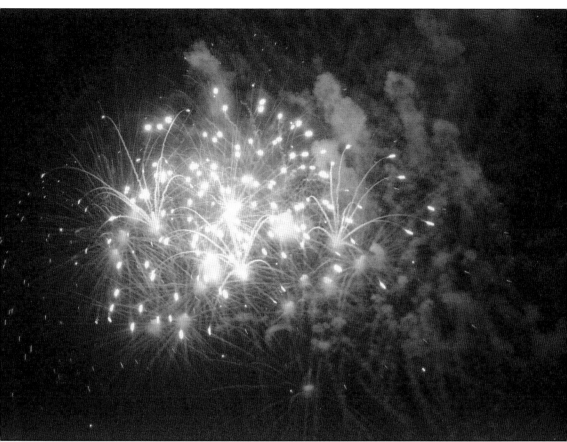

After an afternoon in the park, the city is treated to one of East Texas's most extravagant professional fireworks displays. Local citizens make donations every year to put it on, and it is truly breathtaking. Everyone takes their lawn chairs down to the old steamboat turning basin and watches the rainbow explosions over the bayou. (Courtesy Jefferson Salutes America.)

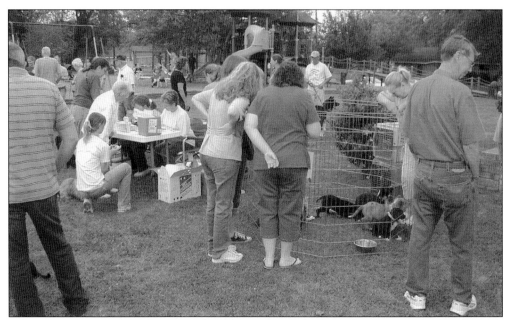

Jefferson is a very pet-friendly city, and residents often walk down the streets and sidewalks with their animal companions. The annual Paws on the Bayou, a celebration of the furry residents of town, is a chance for owners to get vaccinations for their pets or even adopt a new member of the family. (Courtesy Jefferson Paws on the Bayou.)

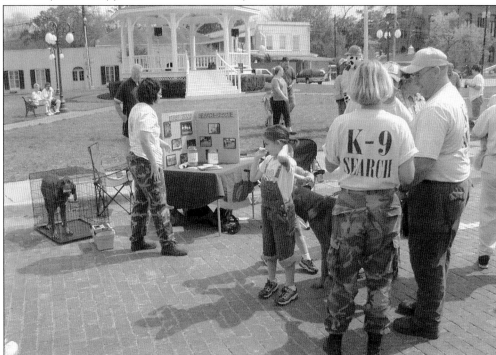

At the festival, one can find all sorts of critters represented as well as pet-related displays ranging from vendors to vets to service-animals. The pinnacle of the day is the Blessing of the Pets, performed by a local minister at the gazebo. (Courtesy Jefferson Paws on the Bayou.)

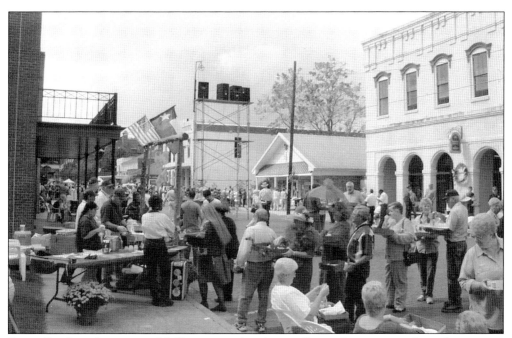

Every October, the streets of Jefferson are closed to traffic, and restaurants from the area are invited to share their wares with the public. A Taste of Jefferson is a festival that brings out locals and visitors alike. (Courtesy Marion County Chamber of Commerce.)

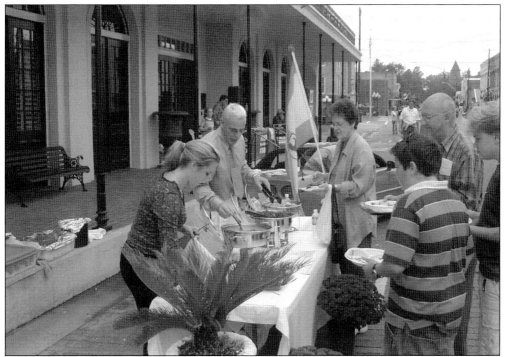

No one leaves hungry, as every eatery dishes out their top-of-the-line entrees and offers samples of their cuisine to the crowd. Along with music and contests, A Taste of Jefferson is an incredible event every year. (Courtesy Marion County Chamber of Commerce.)

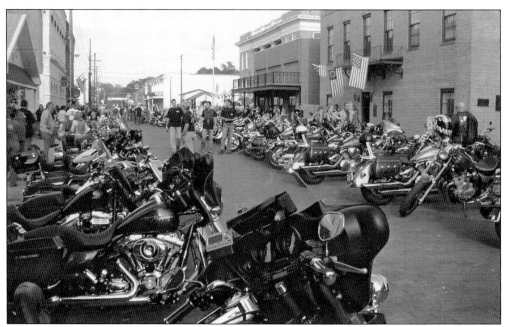

In May 1998, welder Charles "Boo" Chaler was involved in an industrial accident that burned over 95 percent of his body. He loved his motorcycle and riding through the countryside, so several of his friends organized a benefit in his honor while he was still hospitalized at the LSU Burn Center in Shreveport. (Courtesy Boo Benefit.)

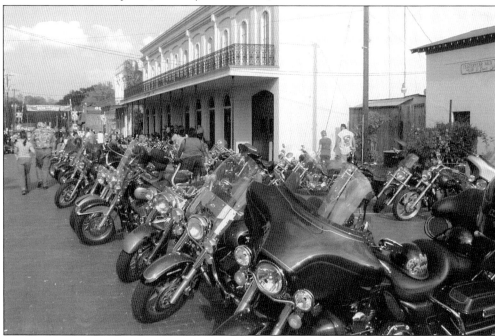

The event was attended by motorcycle enthusiasts from all over the area. It was called the Boo Benefit, and the money was donated to Chaler to help defer his incredible medical expenses. He, in turn, gave the funds over to the Percy Johnson Burn Foundation, a foundation for adolescent burn survivors. (Courtesy Boo Benefit.)

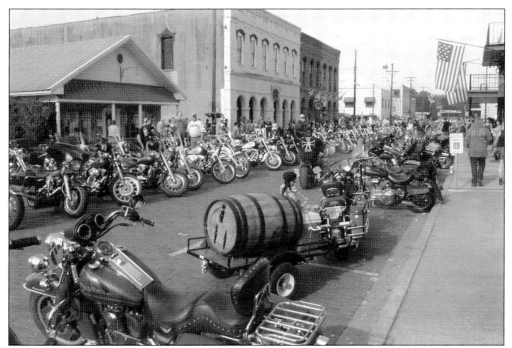

The event has grown into a motorcycle mecca, where the streets of Jefferson are blocked off and thousands of riders come for a good time to benefit a great cause. Attendees see some of the hottest bikes in the country and enjoy events all weekend long. (Courtesy Boo Benefit.)

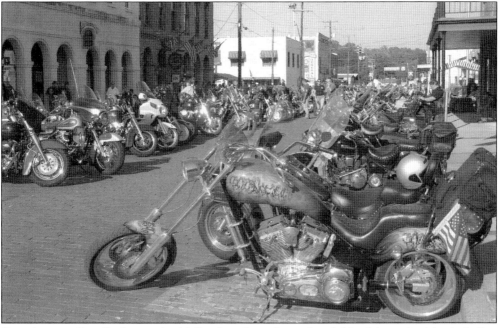

Over the years, literally thousands of dollars have been donated to children's burn charities, including the Percy R. Johnson Burn Foundation; the Chaler-Rods House, which provides lodging for families with patients in the Shreveport burn unit; and Camp I'm Still Me, a facility for adolescent burn victims. The Boo Benefit is held every October in Jefferson. (Courtesy Boo Benefit.)

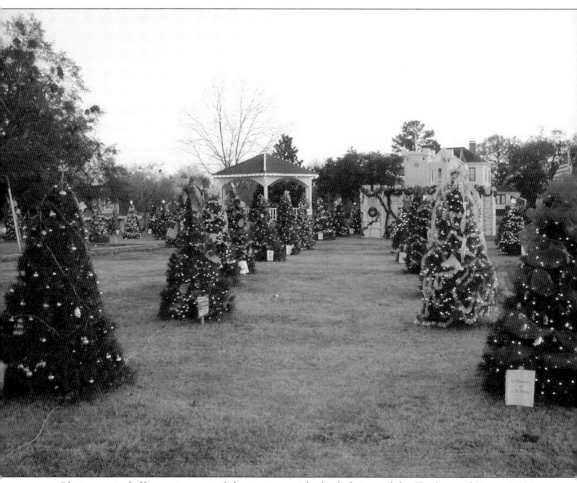

Christmas in Jefferson is magical, beginning with the lighting of the Enchanted Forest in Lions Park. A hundred trees are individually adopted by families and businesses that uniquely decorate and light them. The citizens of Jefferson gather in the park for the event; candles are lit, carols are sung, and Santa himself arrives on a city fire truck to throw the switch for the season. (Courtesy Historic Jefferson Foundation.)

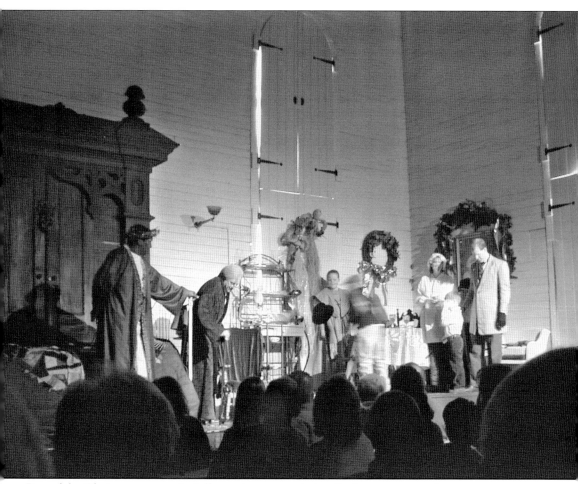

Part of the Christmas season in Jefferson is an annual play. Performances vary from year to year and have included *Miracle on 34th Street*, *A Christmas Story*, and favorite *A Christmas Carol*, as shown above. Performances take place in the historic Jefferson Playhouse. (Courtesy Historic Jefferson Foundation.)

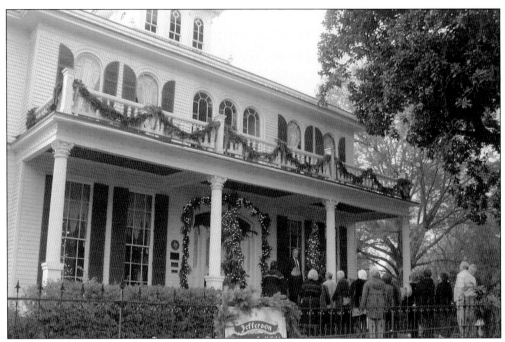

The Candlelight Tour of Homes, held by the Historic Jefferson Foundation, is a popular Christmas attraction. Four homes are selected every year, and each is lavishly decorated with natural greenery and lit by candlelight. (Courtesy Historic Jefferson Foundation.)

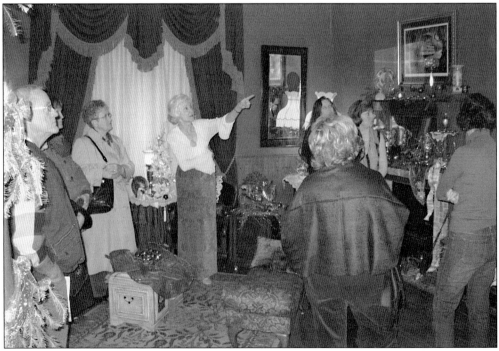

Docents in period costumes guide visitors through the houses and share the history. It is a wonderful opportunity to not only experience part of Jefferson's past, but to celebrate the magic of the Christmas season. (Courtesy Historic Jefferson Foundation.)

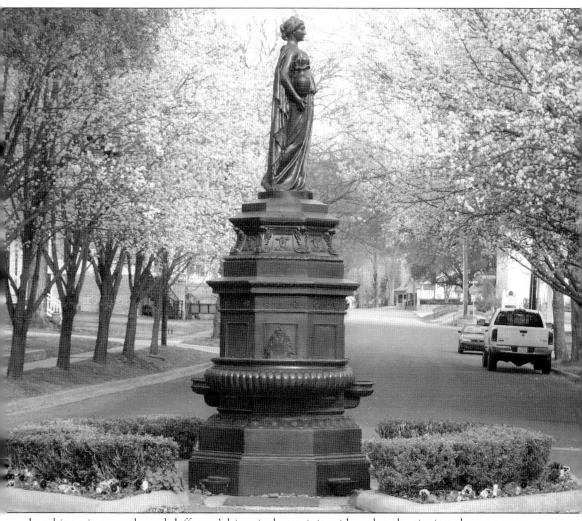

In taking a journey through Jefferson's historical past, it is evident that the city is truly a treasure, not only of the state of Texas or of the South, but of the country. In many ways, it defies definition for it has been so many things at so many different times. Today, however, it is a place where history seems frozen in time—people wave as they pass by and there is a comfortable feeling that simply cannot be described. (Courtesy Jefferson Museum of Measurement and Time.)